Wild
Atlantic
Way

WHERE TO
EAT & STAY

Published by Collins
An imprint of HarperCollins Publishers
Westerhill Road
Bishopbriggs
Glasgow G64 2QT
collins.reference@harpercollins.co.uk
www.harpercollins.co.uk

1st edition 2020

A catalogue record for this book is available from
the British Library.

ISBN 978-0-00-838288-9

10 9 8 7 6 5 4 3 2 1

Printed in China by RR Donnelley APS Co Ltd

MIX
Paper from
responsible sources
FSC™ C007454

This book is produced from independently certified
FSC™ paper to ensure responsible forest management.

For more information visit: www.harpercollins.co.uk/green

Wild

Atlantic

Way

WHERE TO
EAT & STAY

John & Sally McKenna

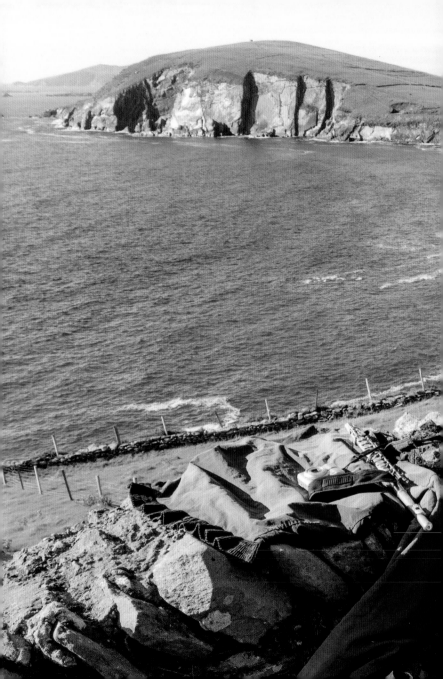

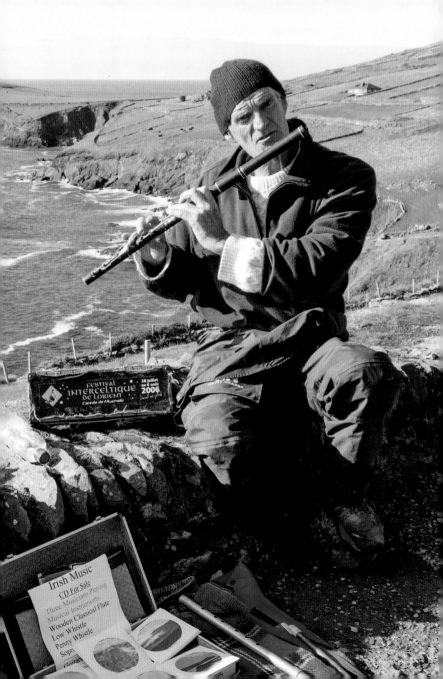

INTRODUCTION

At the most westerly region of the island that forms the most westerly point of Europe, the traveller finds Ireland's Wild Atlantic Way.

The Wild Atlantic Way stretches more than 2,500 kilometres, from the calm coastal waters of Kinsale in County Cork, where Gulf Stream winds bring gentle weather to the Haven Coast, all the way to the stark magnificence of Donegal's Northern Headlands.

Up here, the severity of the winds has earned them a special name: in Donegal you will find the Lazy Wind: too lazy to go around you, it just goes straight through you.

Between these two extremities, the Wild Atlantic Way meanders through a series of separate worlds, united by their proximity to the sea, but otherwise resonantly different.

There are the long, finger-like promontories of the Southern Peninsulas, with lingering drives down to quiet, pastel-painted villages like Eyeries on the Beara Peninsula, or to the festive hub of Dingle.

Heading north, we find the towering immensities of the Cliff Coast, a region defined by its rocks – the ancient deltas of Loop Head, and the extraordinary karstic limestone pavements of The Burren and the Aran Islands. Their severity quickly cedes way to the charms and revelry of Galway city, the place that enjoys the richest food and restaurant culture in the entire country. Go north again, and you enter Connemara. Exactly where and when you enter it, no one knows, as there is no official boundary to Connemara. And yet, you know the very second that you are there, because there is nowhere else like the land that looks upon the mountain range known as the Twelve Bens.

The Bay Coast continues towards Ireland's Holy Mountain, Croagh Patrick, a little ways south of the handsome town of Westport, once voted the best town in the country, and a proud and pretty place.

In County Mayo, the urge is always westwards, to the meandering roads lacing through Achill Island, and the remote wilderness of Erris, once voted the Best Place to Go Wild in Ireland.

Soon, we are in Yeats Country. The great poet's love of Sligo was passed down to him from his mother, Susan, with whom "it was always assumed between her and us that Sligo was more beautiful than other places."

We have toured the Wild Atlantic Way to find the truest hospitality, and the best cooking, and food and friendship characterise this extraordinary route, the most westerly region of the most westerly point of Europe.

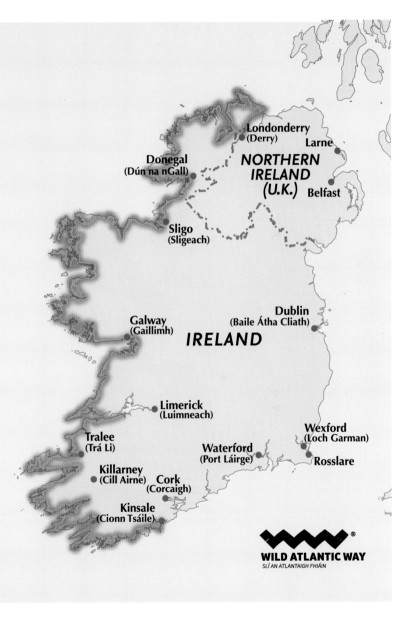

Londonderry
(Derry)

Larne

NORTHERN
IRELAND
(U.K.)

Donegal
(Dún na nGall)

Belfast

Sligo
(Sligeach)

Dublin
(Baile Átha Cliath)

Galway
(Gaillimh)

IRELAND

Limerick
(Luimneach)

Wexford
(Loch Garman)

Tralee
(Trá Li)

Waterford
(Port Láirge)

Rosslare

Killarney
(Cill Airne)

Cork
(Corcaigh)

Kinsale
(Cionn Tsáile)

WILD ATLANTIC WAY
SLÍ AN ATLANTAIGH FHIÁIN

CONTENTS

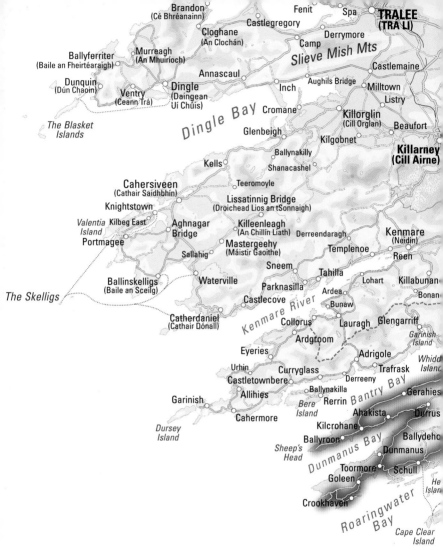

The Haven Coast

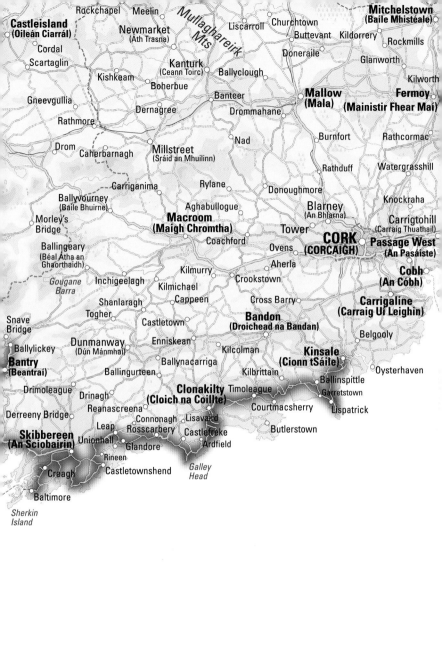

STAY **Actons Hotel**

€€€ Overlooking the Marina, Actons is the oldest hotel in Kinsale, which has developed through several incarnations since opening in 1946 and today is in common ownership with the Trident Hotel, further down Pier Rd. A big refurb in 2013 means the rooms are up-to-the-minute in style, and the views across to Scilly from the rooms at the front are spectacular. Good friendly staff means there is always a happy buzz about the public rooms. A pool and leisure centre is an added bonus. *Pier Rd, Kinsale, Co Cork, actonshotelkinsale.com +353 21 4779900.*

EAT **Bastion**

€€€ Paul McDonald puts an enormous amount of effort into every single plate he sends out from the kitchen in Bastion: cauliflower will be caramelised to perfection; quinoa will be transformed into a cracker; mushrooms will become a crumble; gin will be reborn as a granola. He's a cheffy chef who relishes the intricacy of modern cooking, aiming not just for culinary transformation, but for culinary transubstantiation – he wants to cook for the gods. *Market St, Kinsale, Co Cork, bastionkinsale.com +353 21 4709696. Open dinner.*

EAT **Black Pig**

€€ It may be tucked away from the centre of town but, on any given night, the Black Pig feels like the centre of the culinary action in Kinsale. Gavin and Michelle orchestrate this atmospheric room with aplomb, and the feeling of being expertly looked after is one of the reasons why the 'Pig is such a success, and many people's first choice in Kinsale. Start with Crosshaven oysters, then get stuck into pitch-perfect risotto with Gubbeen chorizo and peas. The wine service couldn't be better, so put yourself in their expert hands and the evening will breeze by in a procession of great discoveries. *66 Lwr O'Connell St, Kinsale, Co Cork @theblackpig-winebar +353 21 4774101. Open dinner.*

STAY **Blindgate House**

€€ The area known as Blind Gate is a nice quiet refuge when Kinsale gets overheated. The conventional exterior of Maeve Coakley's Blindgate House hides one of the most lushly designed and executed interiors in town. But style doesn't win out over comfort, so it's a lovely getaway. *Blindgate, Kinsale, Co Cork, blindgatehouse.com +353 21 4777858.*

EAT & STAY **The Blue Haven**

€€€ The Blue Haven has always been at the centre of Kinsale's food agenda, and it was one of the original members of the Kinsale Good Food Circle. Smart rooms mean the hotel has a neat boutique feel, and downstairs they offer a bar and bistro – with music each night – a seafood café, plus a tapas wine bar. *3 Pearse St, Kinsale, Co Cork, bluehavenkinsale.com +353 21 4772209.*

EAT **Bruno's**

€€ Bruno's is wonderfully atmospheric, the rooms arranged higgledy-piggledy around the slope of the street, and the walls-and-beams style makes it feel like a little enoteca somewhere in Liguria. Vitally, they know how to put that brick oven to the best use, from fine breads to the crisp-based pizza. But their particular speciality is the ingenious use of local artisan ingredients in a host of gleefully creative dishes. Lovely Italian wines. *36 Main St, Kinsale, Co Cork @brunosrestaurantkinsale +353 21 4777138. Open dinner.*

EAT **CRU**

€€€ Colm Ryan has taken the old wine maxim that complex wines work best with simple foods and applied it with expert precision in CRU. The wines are superb, and most of the list is available by the glass, so there is a chance to drink something special with your pan-seared scallops or confit duck with rustic white beans. *Main St, Sleveen, Kinsale, Co Cork, crukinsale.com +353 21 4773357. Open dinner.*

EAT
€€€
Fishy Fishy Restaurant/The Blue Room

Many years ago, Martin Shanahan orchestrated the operation of Fishy Fishy to ensure he was buying the best seafood directly from boats returning to Kinsale harbour. The pristine quality of the fish allows him to keep the cooking simple, which is just as well as Fishy Fishy is so phenomenally busy. You come here to taste the freshest prawns you have ever eaten, the juiciest megrim, the lobster thermidor with house mash, all of them delivered with bomb-proof efficiency by a great team. The Blue Room, at the rear of the restaurant, is a smashing space in which to enjoy seafood tapas and good wines. *Crowley Quay, Kinsale, Co Cork, fishyfishy.ie +353 21 4700415. Open lunch & dinner.*

EAT & STAY
€€€
Jim Edwards

For 45 years, Jim Edwards has been a standard bearer in Kinsale's culinary culture. It's a restaurant with guest rooms where everything chimes sweetly, and one of the places that built Kinsale's reputation as the first town in Ireland to become a dining destination. With Liam Edwards at the helm, the bar and the dining room – and their rooms upstairs – offer everything the visitor to Kinsale is looking for: a great welcome and, of course, good cooking. *Market Quay, Kinsale, Co Cork, jimedwardskinsale. com +353 21 4772541. Open lunch & dinner.*

EAT
€€
The Lemon Leaf Café

The Lemon Leaf stands out as a special destination, even in a town with the standards of Kinsale. The excellent food and drinks, the elegant vibrancy of the room and the carefully chosen foods on the dresser, add to the totality of Tracy Keoghan's smart café. That mid-morning cup of Ariosa coffee will hit the spot, but so will the croque madame, or the sweet potato fishcakes with lime and coriander mayonnaise. Everything is done just right, just so. *70 Main St, Kinsale, Co Cork @LemonLeafCafeKinsale +353 21 4709792. Open daytime.*

STAY
€€€ Long Quay House

Overlooking the pier, Peter and Rasa Deasy's handsome home has eight rooms for guests. Generous breakfasts typify the owners' meticulous attention to detail, and the house has been winning consistent plaudits since Peter and Rasa took over in 2015. *Long Quay, Sleveen, Kinsale, Co Cork, longquayhousekinsale.com +353 21 4709833.*

EAT
€€€ Man Friday

Philip Horgan's restaurant, in Scilly, just across the harbour, has been making people happy for more than four decades, and the menu is a roll-call of classics – stuffed mussels; sirloin steak au poivre; Man Friday fish pie. *Scilly, Kinsale, Co Cork, manfridaykinsale.ie +353 21 4772260. Open dinner.*

EAT
€€€ Max's

Marie and Olivier Queva's Max's has always enjoyed an archetypal restaurant atmosphere, that lovely, welcoming feeling of a restaurant with true restaurant character. The food swerves towards seafood in summertime – langoustines with angel hair pasta; monkfish with cumin and beurre blanc – and then towards game in the autumn – pheasant with choucroute; venison with Brussels sprouts. *48 Main St, Kinsale, Co Cork, maxs.ie +353 21 4772443. Open dinner.*

EAT & STAY
€€ 9 Market Street

Leona and Dee offer cooking that appears simple – sausage rolls, sandwiches; pasta dishes; Wagyu burger – but here's their secret: this cooking is technically super-charged. The consideration and finesse that bring these dishes together is masterful, so that bowl of French onion soup will stop you in your tracks, and their sausage rolls are textbook: perfect pastry, sweet, succulent pork. Three neat rooms upstairs make for excellent lodging. *9 Market St, Kinsale, Co Cork, ninemarketstreet.ie +353 21 4709221. Open lunch & dinner.*

EAT **OHK Cafe**

€ OHK is a blast of punky insouciance in conservative Kinsale, and it comes as no surprise to learn that sisters Sarah and Carol O'Brien both share an art school background. The sisters opened their granny's old pub as a funky café, and the cooking is as darling and defining as the style – sardines tartine; the fine OHK bean burger; Spanish tortilla with harissa aioli; perfect Golden Bean coffee; excellent cakes from Rebecca Mullen in Flour House. OHK is a beauty. *The Glen, Sleveen, Kinsale, Co Cork, oherlihyskinsale.com +353 87 9502411. Open breakfast and lunch. (See photos, pages 12 & 14 - top).*

EAT & STAY **Old Bank House**

€€€ This handsome Georgian house is part of the Blue Haven Collection, owned by local man Ciaran Fitzgerald. The location couldn't be bettered, and as well as rooms they have an all-day café – The Gourmet Café – for coffee and sandwiches and sweet things, with a neat verandah at the front of the house where you can watch the world pass by. There is also a Take Out menu if you want to picnic down by the water's edge. *10 Pearse St, Kinsale, Co Cork, oldbankhousekinsale.com +353 21 4774075.*

Local Speciality — Koko Chocolates

Before Frank Keane switched careers and became an authoritative chocolatier, he dealt in collectable ceramics.

Have a look at his delectable Koko Chocolates, and you will see the sculptural influence of his previous life writ large on every delightful confection that Frank produces, upstairs above the shop in the centre of Kinsale. It goes without saying that the flavour combinations are wow!: gin and tonic with pink peppercorns; the classic seaweed, honey and ginger; the dreamy cardamom with Turkish honeycomb.

STAY **Perryville House**

€€€ Andrew and Laura Corcoran's pretty in pink Perryville House overlooks the pierside as you come into town on the R600. It's a majestic, 200-year-old house, sumptuously comfortable and lavishly appointed. The bar and garden room give guests a charming space in which to relax and enjoy a drink before heading out to dinner. Look out for their many flags. *Long Quay, Kinsale, Co Cork, perryvillehouse.com +353 21 4772731.*

EAT **St Francis Provisions**

€ Barbara Nealon pushes the culinary envelope in the exciting St Francis Provisions. Her toastie, for example, will build a complex structure involving pumpkin butter, honey, candied nuts, apple and taleggio on a base of excellent sourdough, and it makes for a sandwich that is simply mouth music all the way to the last bite. Ms Nealon has learnt well from her time in San Francisco, so St Francis may be a simple room, but there is lavish complexity in everything they do. A real star in the making. *Short Quay, Sleveen, Kinsale, Co Cork @stfranciskinsale +353 83 063 6879. Open lunch and seasonal weekend dinner. (See photos, opposite).*

Local Heroes — 1601 Wine Shop

A number of businesses in Kinsale have annexed their names to the famous Siege of Kinsale, the battle that took place in 1601, with The Spaniard, and local wine store 1601, being two examples. There are scores of splendid wines on offer in the 1601, selected and curated with knowledge and care from the best importers. Along with the wines, all the great modern whiskeys and gins, and a fantastic selection of Irish craft beers pack the shelves from floor to ceiling.

EAT Supper Club

€€€ Tom and Grainne Kay's Supper Club is one of those rooms everybody falls in love with. They love the slick, modern bar and its sympathetic lighting, the atmospheric booths, the comfort of the wood-panelled room. Above all, they love the sincere welcome and hospitality of the Kays, who work super-hard to make everyone feel special. The cooking brings on the feel-good factor: West Cork burger with Baltimore black bacon; roast hake with polenta; salted caramel crème brûlée. Great whiskeys to round off the night. *2 Main St , Kinsale, Co Cork, thesupperclub.ie +353 21 4772847. Open dinner.*

EAT Toddies

€€ Toddies belongs in the league of vintage Irish pubs that do the good thing and do it right. Whilst retaining a dated charm, the bar and restaurant are effortlessly chic. In the winter months, the place is a cosy escape; when the sun shines, it's simply the height of bliss to be in Summercove. Pearse O'Sullivan's cooking, in both the bar and the upstairs restaurant, is confident and delicious: Dublin Bay prawn soup with chilli and lemongrass; skewers of chicken with wasabi coleslaw; the classic lobster risotto. *Summercove, Kinsale, Co Cork, thebulman.ie +353 21 4772131. Open lunch & dinner.*

STAY Trident Hotel

€€€ Could there be a better getaway address for a hotel than World's End? That is where Kinsale's Trident Hotel is located: at the end of the town, at the edge of the sea, as the road heads out to Summercove and the Old Head of Kinsale. It's a magisterial location, and the sea-facing rooms have jaw-dropping views across the water. And thanks in no small part to the lengthy tenure of manager Hal McElroy, The Trident is astutely managed and superbly run by an excellent team. *World's End House, Lwr O'Connell St, Old Fort, Kinsale, Co Cork, tridenthotel.com +353 21 4779300.*

Just Off The Way

The Old Mill Stores

Tom and Claire have such exquisite taste in discovering and choosing beautiful things for your home and office and garden, you will actually want to buy all the things that they have for sale in their handsome store. This is a shop, for instance, that sells the most beautiful clothes pegs. *Connonagh, Leap, theoldmillstores.ie +353 28 34917.*

Galley Head Lighthouse

The Irish Landmark Trust restored two lightkeepers' houses adjacent to the lighthouse itself, which was the most powerful lighthouse in the world when built in 1875. There are two houses, each sleeping 4 people, with a minimum 3-night stay. It's a truly West Cork adventure to stay here, and mighty fun with a bunch of friends. *Galley Head, Co Cork, irishlandmark.com.*

Gougane Barra Hotel

The Lucey family and their team offer hospitality in its most elemental form in their lakeside hotel, up in the woods of Gougane Barra. You could pitch up here, frazzled from the cares of the world, and believe that you had arrived in a fairy tale. A little lakeside hotel, a small church, a forest, a place set apart, and the purest hospitality you could ever imagine. Mr and Mrs Lucey are modest, charming, and hard-working, and they create nothing less than an archetype of Irish hospitality. *Gougane Barra, Co Cork, gouganebarrahotel.com +353 26 47069.*

EAT **Diva Café and Coffee House**

€€ Shannen Butler-Keane is mistress of all the disciplines: a superb baker of sourdough breads and cakes, a great mixologist, and a unique cook whose Americana-style dishes can't be found anywhere else. If you want the finest quesadilla in the country, it's here in Ballinspittle, along with a great veggie burger, flawless tarragon, chicken and hazelnut salad, and some of the best breakfast cooking in County Cork. *Ballinspittle, Co Cork, divaboutiquebakery.com +353 21 4778465. Open daytime.*

EAT **Stranded Café**

€€ Stefania Sapio's café, pizzeria and wine bar, on the promontory overlooking the waves at the surfers' paradise of Garretstown, is the perfect place to chill out after a surf session with some good Roman-style pizza, or maybe their signature double-patty burger, with superlative beef from local food hero Donal Lordan, a genuinely great production. The conservatory is just right when the sun is shining, though they could maybe ditch the maritime stuff that just gets in the way of the splendiferous views. *Garrylucas, Garretstown East, Co Cork @strandedingarrylucas +353 87 6535200. Open weekend lunch and early dinner.*

EAT **Rebecca's Kitchen and Farm Shop**

€ Good food runs in the genes of the Scott family, and Rebecca Scott is the latest family member to show real star talent in her converted barn, just off the coast road near Harbour View beach. Superb ingredients mean that everything from the roast chicken sambo to the pig and hen eats like a dream, the coffees are excellent, and service is sweet and caring. Lots of lovely things to buy in the farm shop seals the deal on a really special place. *Harbour View, Kilbrittain, Co Cork, rebeccaskitchen.ie +353 87 9737901. Open daytime. (See photo page 28).*

Local Heroes — West Cork Markets

West Cork's farmers markets are amongst the very best on the WAW, so every traveller needs to know that on Thursdays you really should visit the Clonakilty market, whilst Friday is the day to be in Wolfe Tone Square in Bantry. Saturday brings one of the true jewels, in the shape of the Skibbereen market, whilst Sunday sees the intimate and delightful little market in the car park at Schull.

EAT **Dillon's**

€€€ Richard Milnes has all the technical skills you would expect of someone with a spell at The Fat Duck on his c.v., but Milnes is, at heart, a countryman, a guy who likes to grow a lot of his own ingredients, a chef who brings the ruddiness of the garden and polytunnel to the plate, best seen in dishes like terrine of ox tongue, or pigeon with polenta, or his superlative beef tartare with pickled cauliflower. The dishes are pretty but, above all, the flavours are powerful. Pretty room, powerhouse cooking. *Mill St, Timoleague, Co Cork, dillonsrestaurant.ie +353 23 8869609. Open dinner & Sun lunch.*

EAT **Monk's Lane**

€€€ Don't let the somewhat ramshackle style of Monk's Lane fool you for a moment. Gavin and Michelle are meticulous, painstaking hosts, and there is nothing in this outstanding gastropub that has not been thought-through and road tested before it is allowed on the menu or on the drinks list. So, you order the fish pie, or the steak salad, or the bangers and mash with craft beer gravy, knowing that each element is considered and executed with abiding care. The same careful eye drives the service, which is exemplary, and the style of the bar, the dining room, the beer garden, and their gin parlour. A country classic, for sure. *Timoleague, Co Cork, monkslane.ie +353 23 8846348. Open lunch & dinner. (See photo opposite, bottom left).*

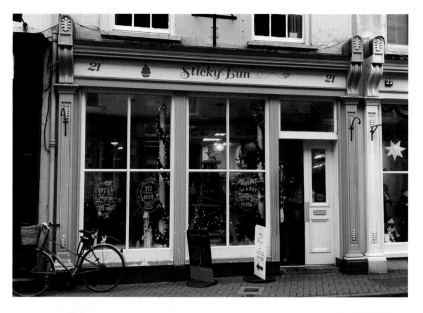

EAT & STAY Inchydoney

€€€ Des O'Dowd and his team are rewriting the book of expectations at the seaside Inchydoney Island, and Mr O'Dowd is a fortunate hotelier to have one of the best crews working together to raise the bar at every step. The hotel has matured beautifully over the years, so that today every element of the operation – welcome; food; hospitality; the spa; the beachside setting – works compatibly, and it all adds up to a very special getaway in a very special setting on the Wild Atlantic Way. *Clonakilty, Co Cork inchydoneyisland.com +353 23 8833143.*

EAT Sticky Bun

€ There is a sense of true finesse in the foods that Kay Burke and her team offer in The Sticky Bun. You see it in the way in which that chocolate hazelnut brownie is just right: intense, teasingly toothsome, sweet but not too sweet. Or the excellence of the crispy, crunchy and sticky pavlova, or a little tart of Gruyère and dill, served with some sweet-sour cucumber pickle. This is simple food, but it is no simple thing to deliver it with such calm perfection, with such understanding and authority. *21 Rossa Street, Clonakilty, Co Cork @stickybunclon +353 23 8835644. Open daytime. (See photo page 27).*

STAY Fernhill House Hotel

€€€ Charm, character and community are the triptych of values that make Michael O'Neill's hotel a rather special place. Located at the edge of the town of Clonakilty, and set amidst lush and lavishly tended gardens, Fernhill is the sort of hotel that gives family-run, local community hotels a good name. What we also like is the fact that Mr O'Neill and his team are real strivers, always determined to get better, to be their best, always going the extra mile to offer guests the best possible experience. Charm, character, and a massive part of the West Cork community: that's Fernhill House Hotel. *Clonakilty, Co Cork, fernhillhousehotel.com +353 23 8833258.*

EAT **Lettercollum Kitchen Project**
€ For more than 25 years, Con and Karen's Lettercollum Kitchen has been one of the defining West Cork destinations, a place where you discover transcendent food, served by people who wear their alternative philosophy lightly. Nobody – but nobody – makes better pastry than these guys, but then everything they send out to the folk sitting on the small collation of chairs in the café is blessed with goodness, healthfulness, and with a unique signature: there is no other cooking like Lettercollum cooking. *22 Connolly St, Clonakilty, Co Cork, lettercollum.ie +353 23 8836938. Open daytime.*

EAT **Hart's Coffee Shop**
€ Aileen Hart's little tea room and lunch stop is a beacon of excellence, and the boss and her team do everything right, from the excellent scones to the classic steak baguette. *8 Ashe St, Clonakilty, Co Cork, hartscafeclonakilty.com +353 23 8835583. Open daytime.*

EAT **Scannells**
€€ Scannells is the archetype of the modern Irish country pub: creative, sociable, surprising, ambitious, and delightful. You might be impressed at first by its pristine interior, by the charm of the staff, by the comfort of the rooms. But a quick glance at the menu shows just how cool this Clonakilty landmark really is, for the food is top notch. A class act. *5 Connolly St, Clonakilty, Co Cork, scannells.ie +353 23 8834116. Open lunch & dinner.*

EAT & STAY **An Sugan**
€€ The O'Crowley family offer both restaurant and accommodation at their handsome bar and guesthouse, one of the pioneers of good food in West Cork. Popular cooking in the bar includes West Cork Seafood Pie. *41 Wolfe Tone St, Clonakilty, Co Cork, ansugan.com +353 23 8833719. Open lunch & dinner.*

EAT **Richy's Restaurant & Cafe**

€€ Richy's offers everything from breakfast through to dinner, with lots of unusual touches – tamarind sauce with fried chicken; silken tofu with sweet potato; cauliflower steak with bean salsa. *Wolfe Tone St, Clonakilty, Co Cork, richysrestaurant.com +353 23 8821852. Open daytime & dinner.*

STAY **Dunowen House**

€€€ "Perhaps it was our naivety that made this project work," Kela Hodgins explained to *The Irish Times* about their heroic endeavour in restoring the legendary Dunowen House. Naivety has nothing to do with it. Kela and Stephen Hodgins are simply blessed with great taste, which explains why Dunowen is one of the most sought-after getaways in Ireland. It is a peach of a destination, and the Hodgins deserve to win every design award going for their meticulous curation. That curation, with its exhaustive attention to detail, explains why no one who stays here wants to leave. *Clonakilty, Co Cork, dunowenhouse.ie +353 23 8869099.*

EAT **Wilde & Co**

€€ Michael O'Donovan is a Clonakilty native who returned to his home town and opened the much-admired Wilde & Co in a transformed old pub. It's a classy destination, with great coffee, and menus that showcase the produce of local food heroes in sparklingly fresh salads and imaginative sandwiches. The sweet treats are particularly fine, not least the beetroot and chocolate ganache. *42 Pearse St, Clonakilty, Co Cork +353 23 8835692. Open daytime.*

EAT **Chunky Chip**

€ Superbly fried chips cooked in beef fat: crisp, dry, luscious, and a stylish room in which to enjoy them. They only offer one fish – hake – but they cook it beautifully. *1 Western Rd, Clonakilty, Co Cork @ thechunkychip. Open daytime & dinner.*

Local Heroes — Field's & Scally's

Only in West Cork would you find local supermarkets that can rival the finest food stores anywhere in the world. Both Scally's of Clonakilty and Field's of Skibbereen are shops which astonish the first-time visitor to West Cork: the range of local produce! The amazing staff! The lovely coffee shops! These SuperValu shops are unmissable destinations, true food heroes of the West Cork food culture.

EAT **The Fish Basket Longstrand**

€ Count the numbers! *The Irish Examiner* gave The Fish Basket no less than 11/10 for atmosphere in its review of Peter Shanahan's packed-to-the-rafters beach hut on Long Strand. It's just a tiny, on-the-beach room with lots of outdoor seating to accommodate the crowds, all of whom want herb-buttery crab claws and prawns and a big sharing tray with perfect scampi and crisp calamari. Nice wines, good sweet things and charming service bring the whole idyllic seaside experience to a blissful conclusion. *Longstrand Beach, Castlefreke, Rosscarbery +353 23 8851716. Open daytime till 8pm. (See photo page 34)*

EAT **Pilgrim's**

€€€ No one else cooks the way Mark Jennings does. His food in Pilgrim's, a pretty room on the square in Rosscarbery where Sarah Jane Pearce runs front of house, gives you flavour combinations you will not find anywhere else. Pumpkin and leek parcel with sprout tops, hazelnut and a beetroot anise cream is a typical Jennings dish: intriguing, off-kilter, slightly hallucinogenic in its disciplined but wayward way. He's a jazzer in a room of squares, playing blue notes – pickled grapefruit with crab; smoked tomato butter with Angus steak – and strange time signatures. He's a maverick, and Pilgrim's is many food lovers' first choice in West Cork. *South Sq, Rosscarbery, Co Cork, pilgrims.ie +353 23 8831796. Open dinner & Sun lunch. (See photos opposite).*

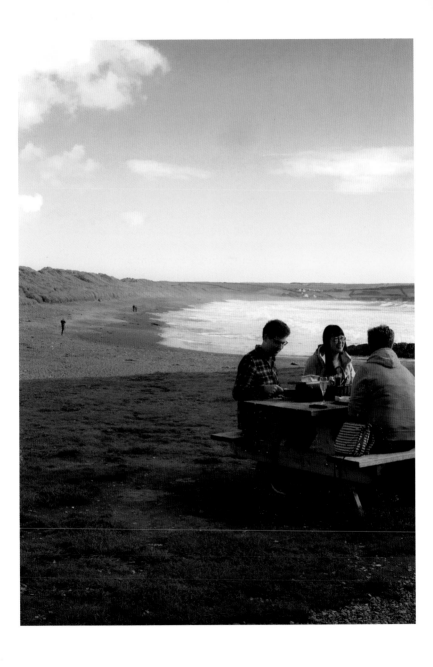

EAT & STAY
€€€ Celtic Ross Hotel

The Celtic Ross is classified as a 3-star hotel, but it's a 3-star that boasts 5-star ambition, and it's a winning West Cork landmark on the WAW. Manager Neil Grant and chef Alex Petit have towering ambitions, and the restyling of the Kingfisher Bistro and the hotel's public spaces have gifted it with the style to match the ambition. Their Wild Atlantic Way menus are particularly imaginative, built on the foundation of superlative West Cork ingredients. Excellent afternoon teas also. *Rosscarbery, Co Cork, celticrosshotel.com +353 23 8848722.*

EAT
€€ Hayes' Bar & Kitchen

Everyone wants to be sitting at one of the tables outside Hayes' Bar on a sunshiny West Cork day, enjoying the seafood tagliatelle and the utterly stupendous views. David cooks classic dishes with precision and flair whilst Julie looks after everyone, and don't worry if you can't get a table outside: the bar itself is a charmer. *The Square, Glandore, Co Cork, hayesrestaurant.ie +353 28 33214. Open lunch & dinner.*

EAT
€€ Connolly's of Leap

Connolly's is a legendary West Cork music destination, and Sam McNicholl has been stepping up the food offer with some seriously tasty pizzas from their wood-fired oven. Great craft beers, ace sounds, and a fantastic space. *Main St, Leap, Co Cork, connollysofleap.com +353 28 33215. Open afternoons & dinner & weekend lunch.*

EAT
€ O'Neill Coffee

Colm Crowley sources his beans from two local West Cork roasteries – West Cork Coffee and Red Strand Coffee – and his sweet and savoury tastes come from the best local bakeries. Put these in a darling little old grocery shop, and you have the hippest place in town. *64 Townshend St, Skibbereen, Co Cork @oneillcoffee +353 86 3334562.*

EAT & STAY
€€€
West Cork Hotel

The West Cork Hotel is a pure charmer, an abiding echo of the days when local hotels were the centre of the community. It's both a lovely place to stay, and a base for exploring all over West Cork. *Ilen St, Skibbereen, Co Cork, westcorkhotel.com +353 28 21277.*

EAT
€
The Coffee Shop at Uillinn

Jessie Kennedy knows the good things and knows how to present them, so her food is filled with flavour, colour and vivaciousness and the ability to hit the spot every time. The room is quite lovely, at the Arts Centre (aka the "rushty building"), and the verandah is jammers when the sun comes out. *West Cork Arts Centre, Skibbereen, Co Cork @TheCoffeeShopatUillinn +353 83 3086569. Open daytime.*

EAT
€
Kalbo's

Siobhan O'Callaghan is one of the best cooks in West Cork, and everything cooked in the closet-sized space of Kalbo's enjoys her signature of superb sourcing and experienced kitchen skills. The sausage rolls use their own free-range pork, and the brownies are just the best. *49 North St, Skibbereen, Co Cork, kalboscafe.com +353 28 21515. Open daytime.*

EAT & STAY
€€€
Casey's of Baltimore

The Independent described Casey's as having "an easy charm about it that's rather lovely." It's a modest, professional hotel, with fine comfortable rooms. There is also accommodation in The Lodge, The Cottage and The Townhouse, and the hotel offers good fish cookery and the produce of their organic vegetable garden. It is also the best place in which to enjoy the beers of the hotel's own brewery, The West Cork Brewing Company. Nothing like a Sherkin Lass after a day touring the WAW. *Baltimore, Co Cork, caseysofbaltimore.com +353 28 20197.*

Max speed 5 knots / no wash

5

Knots

Uas-Luas de 5 muirmhíle

EAT Glebe Gardens
€€ The Glebe is one of the defining West Cork destinations, one of those unlikely and superlative places that epitomise the shaggy artfulness of the region and its culinary creatives. The four Perry sisters cook delicious food, much of it from the Glebe Gardens – grilled cucumber with nasturtium; Walsh's lamb with rainbow chard; pollock with dillisk and onion sauce. It is worth going all the way to Baltimore just to have their classic lemon curd meringue cake. The gardens and courtyard are simply heavenly. *Ballylinch, Baltimore, Co Cork, glebegardens.com +353 28 20579. Open daytime.*

EAT & STAY Rolf's
€€€ Johannes and Frederike have a characterful restaurant and splendid rooms in this lively and unpretentious hostelry, which has been a staple of Baltimore for decades, ever since the Haffner family opened in 1979. The place has changed much over the years, but it has always been characterful and fun, and the good cooking by Johannes brings in the West Cork locals as well as summertime visitors to Baltimore. *Baltimore, Co Cork, rolfscountryhouse.com +353 28 20289.*

EAT Mews Restaurant
€€€ Ahmet Dede's glorious cooking has built a solid and appreciative audience for The Mews over the last few years. Ownership changes appear imminent as we go to press. *Baltimore, Co Cork , mewsrestaurant.ie +353 28 20572. Open dinner.*

EAT Antonio's
€€ Antonio's charismatic mix of unfussy Italian food and good pizzas is a winning formula. Their signature pasta dishes are really fine, and an evening here is great theatre, and great fun. *Main St, Ballydehob, Co Cork, antonioristorante.ie +353 28 37139. Open dinner.*

EAT **Bally Bia**

€€ Head chef Faye offers some seriously delicious cooking in the little space that is Bally Bia. The confident authority she brings to dishes such as beef rendang or massaman curry is utterly convincing, and the Bally Bia burger is as deft a dish as you will find in West Cork. The room is tiny, candlelit and charming, and value is excellent. A real winner. *Staball Hill, Ballydehob, Co Cork @ballybia +353 87 7039198. Open lunch & dinner.*

EAT **Budds**

€€ Budds is buzzing, so don't be surprised if you arrive and have to wait for a table. Ballydehob is home to a close-knit community, and Budds has placed itself at the heart of this sociable bunch of left-field folk, with its artisan cheese and meat boards and buffalo burgers, good coffees and relaxed atmosphere. *Main St, Ballydehob, Co Cork, budds.ie +353 28 25842. Open daytime and weekend dInner.*

EAT **Hudson's Wholefoods**

€ Hudson's is one of the great West Cork destinations, both an excellent wholefood shop, and a punky, artful café with some lovely vegetarian cooking – sweet potato and coconut soup; onion, aubergine and ricotta tart – and their sandwiches and baps are a total treat. *Main St, Ballydehob, Co Cork @ hudsonsballydehob +353 28 37565. Open daytime.*

Local Speciality — West Cork's Coffee Roasters

West Cork Coffee: Tony Speight's coffee company roasts in Innishannon, in a renovated Georgian blacksmith's forge, westcorkcoffee.ie.

Stone Valley Roasters: John and Tom roast the beans and brew fine cups of coffee to take away at their roastery on Ashe Street, Clonakilty, stonevalleyroasters.com.

Red Strand Coffee: Shane's Red Strand coffee cart is one of the great staples of West Cork's food culture, so join the queue in Clonakilty to get a perfectly roasted and curated cup of coffee, @redstrandcoffee.

EAT Restaurant Chestnut

€€€ Robbie Krawczyk's cooking is contemplative. Where most chefs want to grab you by the lapels with their cooking, Mr Krawczyk's food whispers, quietly. Other chefs pile on ingredients until they reach abundance, but Krawczyk offers subtraction, distilling the focus on his West Cork ingredients: a little piece of octopus with cauliflower; wild deer with salsify; chocolate with beetroot. His maturity as a chef shines through in the fact that he hides the techniques that create his artful dishes and his food has moved further and further from culinary artifice, and closer to culinary essence. This is cooking of rare purity. Elaine runs the room with deft accomplishment. *Staball Hill, Ballydehob, Co Cork restaurantchestnutwestcork.ie +353 28 25766. Open dinner. (See photos, opposite)*

EAT Levis Corner House

€ Levis is a century-old country pub with a century-old tradition of hospitality, a lovely little place where in recent years Joe and Caroline O'Leary have amplified the hospitality, whilst also creating one of the great music session venues, and a marketplace where you can pick up some organically grown West Cork vegetables. Mixing the traditional with the contemporary means that Joe and Caroline have created a whole new template for the Irish pub, and their inspired work is fitting tribute to Joe's great aunts, Nell and Julia, who ran the pub for many decades. *Main St, Ballydehob, Co Cork, leviscornerhouse.com +353 28 37118.*

EAT & STAY Grove House

€€ Katarina Runske's house is whacky, charming and unique. There are five lovely rooms, and excellent cooking in the restaurant, from a salad featuring the local Gubbeen cheese to pork schnitzel. Grove House is your destination on the Mizen. *Barrys Rd, Schull, Co Cork, grovehouseschull.com +353 87 2494722. Open dinner.*

EAT **Nico's Street Kitchen**

€ Some cooks have the right feel for food, and Nico, who runs Nico's Street Food in Schull, West Cork, is one of those cooks. What he does is simple – burgers; wraps; hot dogs; sausage rolls – but the way he does it isn't simple. In fact, it's complex, tactile, and pretty darn fantastic. *Pier Rd, Schull, Co Cork +353 86 0875050. Open daytime & early dinner May-Sept.*

EAT **Hackett's Bar**

€ Take every praiseworthy characteristic of the Irish pub – democratic; spontaneous; generous; sociable; wild; nostalgic; cossetting – and you have to amplify all those characteristics to explain the charm of Hackett's bar, with its stone floor, its artworks, its punky staff, its excellent drinks and its soulful, vivid cooking. Hackett's has the warmth of a hearth – you are drawn to it as you are drawn to a crackling fire, all energy and comfort. *Main St, Schull, Co Cork @Hackett'sBar +353 28 28625. Serves food at lunchtime.*

EAT **Paradise Crepe**

€ Gwen Perroud's fine crepes demonstrate the true Breton appreciation and sensibility of this demanding culinary art form. Bring a healthy appetite as these are large crepes. Nice wines, and a lovely terrace out back for the fine weather. *Main Street, Schull, Co Cork @ParadiseCrepe. Open lunch.*

STAY **Fortview**

€€ There is only one problem with Violet Connell's lovely Fortview House: once you stay there, you don't want to leave. It's a commonplace to hear people describe Fortview as "the best B&B", as they head off having enjoyed meticulous breakfast cookery, superb hospitality, and the very mature style of this fine farmhouse. Delightful. *Gurtyowen, Toormore, Goleen, Co Cork, fortviewhouse.ie +353 28 35324.*

EAT **Crookhaven Inn**

€€ Emma and Freddy's bar and restaurant is the sort of destination you dream of finding when travelling the WAW. It's simple but real, a place of tactile charm, and with stonkingly fine cooking. They know that God is in the detail, which is why the dill mayo with the crab on brown bread is so fine, and why that little shot of mustard perks up the perfect ham and cheese toastie. A seat outside on a sunny day overlooking the harbour is pure West Cork bliss, and smart staff do their job to perfection. *Crookhaven, Co Cork, thecrookhaveninn.com +353 28 35309. Open lunch & dinner.*

EAT **O'Sullivan's**

€€ Plates of toasted sandwiches, bowls of chowder, pints of stout, and chats with the nautical types who colonise the idyllic port of Crookhaven during the summer, is the order of the day in Dermot O'Sullivan's classic bar, which announces itself as serving 'the most southerly pint in Ireland'. The bar is festooned with ancient currency notes left by visitors from all over the globe, and the next door Nottages bar and restaurant is run by the same family. *Crookhaven, Co Cork, osullivanscrookhaven. ie +353 28 35319. Open daytime and dinner.*

Local Heroes — Wild Atlantic Way Washed-Rind Cheeses

Milleens Farmhouse Cheese was created in Eyeries, on the Beara Peninsula, by Veronica Steele. Durrus Farmhouse Cheese was created by Jeffa Gill, up the hill of Coomkeen, just outside Durrus on the Sheep's Head Peninsula. Gubbeen Farmhouse Cheese was created by Giana Ferguson, at Gubbeen farm, just outside Schull, on the Mizen Peninsula. On these three remote West Cork peninsulas, this mighty trinity of women changed the way Irish people thought about milk, about cheese, about farming, and about food. The cheeses are united by being semi-soft, washed-rind cheeses. Otherwise they are as different and distinct as their creators, but they remain united in being iconoclastic, unpredictable, and artful expressions of three great artists at work, mistresses of their medium.

EAT & STAY
Blairscove House

€€€ In the beautiful Blairscove, you almost need a pair of Wayfarers to protect your eyes from the gleam and the glow and the spit and polish of the house-keeping. This is a house, from restaurant to rooms, that is so well loved-up that you just can't help but be bowled over by it, and the hospitality from Ann and Woody just drives home the sense of blissful comfort. The dining room may well be the most beautiful room in which to eat in the entire country of Ireland and the cooking is top notch – there were no fewer than 24 starters on the buffet table on a recent visit – and the open fire meat cookery is particularly fine. Breakfast, served in your room, is a treat for the ages. You will not want to leave Blairscove House. *Durrus, Co Cork, blairscove.ie +353 27 61127. Open dinner. (See photo, opposite).*

STAY
Carbery Cottage

€€ Carbery Cottage is an especially welcoming West Cork escape, a pretty house wedged cosily into the hillside overlooking the serene and lovely Dunmanus Bay on the Sheep's Head peninsula. Mike and Julia are two cultured and informed people, coming from the diverse worlds of the Merchant Navy, and the theatre. Mike's cooking, for the special dinners he arranges for guests, creates memorable events that you really should not miss, and breakfast is a wealth of delicious local goodness, and attentive care. *Brahalish, Durrus, Co Cork carbery-cottage-guest-lodge.net +353 27 61368.*

STAY
Gallan Mor

€€ Lorna and Noel's purpose-built B&B is on the eastern ridge of the Sheep's Head Peninsula, so it's the perfect base for anyone who wishes to walk the entire Sheep's Head Way. The house sits on a small hill overlooking Dunmanus Bay, offering the visitor jaw-dropping views over the water. *Kealties, Durrus, Co Cork, gallanmor.com +353 27 62732. Two-night minimum stay throughout the year.*

EAT **Arundel's by the Pier**

€€ Arundel's bar and restaurant has a drop-dead gorgeous location, and to enjoy something tasty sitting across the road in the garden at the water's edge on a sunny West Cork day is an experience that is hard to beat. They serve bar food downstairs, whilst the restaurant is upstairs. Don't miss the signature dish of Durrus cheese fritters served with poached pears and salad. *Kitchen Cove, Ahakista, Co Cork arundelsbythepier.com +353 27 67033. Open lunch & dinner.*

EAT **The Heron Gallery and Café**

€ Annabel Langrish has opened galleries in both Schull and Kinsale in addition to her original gallery in Ahakista. Ms Langrish is a one-woman powerhouse, and somehow also manages to find time to run a lovely wholefood café beside the gallery, in addition to maintaining a superb garden, so this is a great stop for lovely food and a tour of both gallery and garden. *Ahakista, Co Cork, herongallery.ie +353 27 67278. Open daytime.*

EAT **The Tin Pub**

€ Its proper title is The Ahakista Bar but, because it's roofed with corrugated iron, the locals all know it as The Tin Pub. A drink here is an elemental part of touring the Sheep's Head peninsula, enjoying the beer garden as it slopes down to Ahakista Bay and Kitchen Cove, with the most stunning views across Dunmanus Bay to the Mizen Peninsula. *Ahakista, Durrus, Co Cork, @TheTinPub +353 27 67337.*

EAT **The Old Creamery**

€€ Eleanor and Mary Anne do a lovely job in their café and restaurant, just at the bridge in Kilcrohane, and enjoying tea and scones or lunch here if you have rented an electric bike to explore the Sheep's Head peninsula is the way to have the perfect West Cork day. *Kilcrohane, Bantry, Co Cork @theoldcreamery +353 27 67139. Open daytime & Sat dinner. Seasonal.*

EAT **Eileen's Bar**

€ Eileen's is a gorgeous pub. If you've just walked down the hill after a hike around the Sheep's Head, it's the place for sitting by the fire. The atmosphere is great, and there are nice things to eat. *Kilcrohane, Co Cork @Eileen'sBar +353 27 67057.*

EAT **Bernie's Cupán Tae**

€ At the end of the Sheep's Head Way, at the end of Europe, there is a room with a table and on it there is a cup of tea, and a salmon sandwich, that both have your name on them. If you have hiked down to Tooreen, with the lighthouse as your destination, then the tea and the sandwich waiting in Bernie Tobin's tea room will taste like the greatest thing you have eaten in your life. *Tooreen Car Park, Sheep's Head, Co Cork +353 27 67878. Open daytime, but telephone before travelling.*

EAT **The Snug and O'D's Pub**

€€ No bar in Ireland is as well named as The Snug, an always-welcoming destination, a place for good food and good pints. Whether you are having a quiet lunch of bacon and cabbage, or a dinner of fresh fish with a few pints, The Snug feels just right. Their restaurant room – O'D's – has gifted them with much needed extra seating. *The Quay, Bantry, Co Cork thesnug.ie +353 27 50057. Open lunch & dinner.*

EAT **Organico Cafe**

€ Even after more than 20 years of service, Organico exudes a just-born energy, thanks to its owners, Hannah and Rachel Dare, and their team of wise, witty women – and the occasional man – who run the shop and the café with charm and exactitude. The cooking in the café is as smart as smart gets, whilst the shop and bakery has everything you could possibly need. Organico is the best double act in West Cork and should not be missed. *3 Glengarriff Rd, Bantry, Co Cork, organico.ie +353 27 55905. Open daytime.*

EAT **The Fish Kitchen**

€€ Quiet, modest restaurants are the ones we like the best, the places that you can return to, time after time, and know that the cooking will be soulful and satisfying, the service will be friendly and unpretentious, and that the bill will be modest. Bantry's The Fish Kitchen pushes all those buttons. Anne Marie and her team cook excellent food, and serve it in a welcoming room. Lovely. *Bantry, Co Cork, thefishkitchen.ie +353 27 56651. Open lunch & dinner.*

EAT **Box of Frogs**

€ This friendly and engaging community café is a real charmer. *Bridewell Lane, Bantry, Co Cork, boxoffrogs.ie +353 27 56344. Open daytime.*

EAT **Stuffed Olive**

€ The defining characteristic of every great food business is the fact that, as time passes, the business gets better and better. That's the story of Bantry's iconic The Stuffed Olive, where Trish and all the team continue to learn, develop and improve, all the better to offer an outstanding service to their customers. But being self-critical and ambitious doesn't mean that the Stuffed Olive team are po-faced about their work: if you could power a business on peals of laughter alone, The Stuffed Olive would get home with gas in the tank. It all makes for one of the happiest rooms in which to eat on the Wild Atlantic Way. Don't miss the sourdough breads on Friday. *Bantry, Co Cork @TheStuffedOlive +353 27 55883. Open daytime.*

EAT **Ma Murphy's Bar**

€ Sean and Mary make everyone welcome in Bantry's classic bar, a lovely warren of rooms and nooks and snugs, and a bar that is as authentic as it gets. A fantastic range of local craft beers puts the cherry on the cake. *New St, Bantry, Co Cork @MaMurphys-Bar +353 27 50242.*

EAT Wharton's

€ This pristine café is home to the best fish and chips you can find in Bantry, all expertly made to order, and cooked with craft and care by excellent staff. Even the vinegar is organic, and the chips are cooked in lard. *New Street, Bantry, Co Cork, @whartonstakeaway +353 87 126 9655. Open lunch & dinner.*

EAT Manning's Emporium

€€ When people talk about 'West Cork', they are really talking about the sort of experience you enjoy in Manning's. From the outside, it looks like a standard country grocer's shop. But then you notice the pizza oven, and the serious coffee machine, and the tapas menu and, if you've arrived early, you might decide to have Eggs Royale on sourdough topped with smoked salmon for brunch, maybe with a glass of fino. And you ask yourself: how can they manage to do this in a country grocer's shop? But managing the magic is part of the West Cork thing that Laura and Andrew Heath and Val Manning all conjure up, seemingly out of the ether. *Ballylickey, Bantry, Co Cork, manningsemporium.ie +353 27 50456. Open daytime and dinner.*

STAY Seaview House Hotel

€€€ It's always a great day when a grand institution passes to a new generation, with the new incumbents building respectfully on the work of their predecessor, whilst creating a new dynamic of their own. This is the story in Bantry's gracious Seaview House Hotel, now run by Ronan O'Sullivan and his wife Suzanne, the third generation of O'Sullivans to welcome guests to this charming manor. The addition of the Bath House is a perfect fit in this elegant but democratic house, and Seaview is an ageless delight. *Ballylickey, Bantry, Co Cork, seaviewhousehotel.com +353 27 50073. (See photo, opposite).*

The Southern Islands of the Wild Atlantic Way

Sherkin Island

Sherkin is one of the inhabited islands around Ireland's coastline, with a population of about 100. The island is 4.8km long and is home to an Art School, awarding a BA in Visual Art in a 4-year honours degree programme. There are two pubs, self-catering cottages and an excellent hostel and retreat centre. The island landscape is a mixture of heathlands, salt marshes and glorious beaches. The Sherkin Island Marine Station has made a significant contribution to the marine life of West Cork, producing a series of useful nature guides. Sherkin is a place where Irish music is played in lively sessions, especially in the summer months.

The Jolly Roger @TheJollyRogerPub

Heir Island

This island is one of the inner islands in Roaringwater Bay, a swimmable distance from Cunnamore Pier, 14km S of Skibbereen. The island is 2.5km long — easy also to circumnavigate by kayak. The island boasts a Bread Cookery School and a well-known restaurant, which now also functions as an Art Gallery, displaying the work of chef and artist, John Desmond. Island Cottage, the restaurant he runs with partner Ellmary Fenton is internationally known. Dinner is served Wed-Sun between the months Jun-Sept. Pre booking essential, fixed menu. The Firehouse Bread School operates a Saturday bread baking course where students learn a range of techniques and recipes, and pizzas are cooked in their wood-fired oven.

Island Cottage islandcottage.com
The Firehouse Bread School thefirehouse.ie

Cape Clear

Cape Clear is an Irish-speaking Gaeltacht island, where many a school child has completed summer camps in an effort to get to grips with the language. The most southern of West Cork's group of islands, it is accessed from Baltimore, landing at the beautiful harbour on its N side. A magical island of Megalithic standing stones, characterful ruins and a centre for bird watching and spotting whales, turtles, sunfish, dolphins and sharks. There are about 120 people living on the island, speaking both English and Irish. One of the main attractions of the island is the Goat Farm, run by blind goat herder, Ed Harper. The farm is open to visitors and you can buy their delicious homemade goat's ice cream. Sean Rua's Restaurant, operating also as a shop, is a recommended stop for a pizza or some really fresh fish and Cotter's Bar is the island pub.

Cape Clear Goat Farm goat@iol.ie
Sean Rua's Restaurant seanruasrestaurant.com

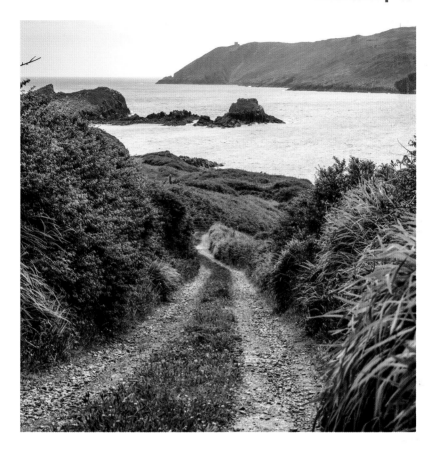

Whiddy Island

Once a centre for curing pilchards, Whiddy Island, in beautiful Bantry Bay, now has an economy driven by fishing and tourism, but the island is also home to a large oil terminal, which stores a strategic reserve of oil for Ireland. Sadly, the island is also known for the Whiddy Island Disaster, when a tanker landing with crude oil exploded on the terminal, killing 50 people. Bantry moved on from the disaster, and the location became the home of Bantry Bay mussel farming. It is an island visited by locals on a summer's day, and there is a restaurant, which is operated by the same family that runs the ferry.

Whiddy Ferry and Bank House
whiddyferry.com

Southern
Peninsulas

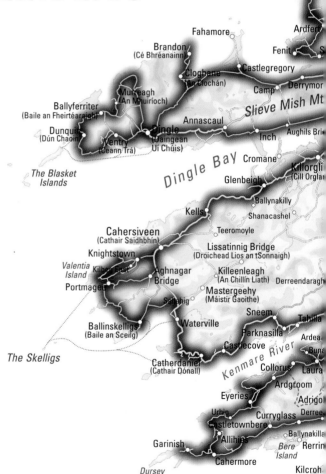

Feeard
Cro
Kilbaha
Mou

Ballynaskreen
Dreenagh
Ballyheigue

Ardfert
Fahamore
Fenit
S
Brandon
(Cé Bhréanainn)
Cloghane
(An Clochán)
Castlegregory
Murreagh
(An Mhuiríoch)
Camp
Derrymor
Ballyferriter
(Baile an Fheirtéaraigh)
Annascaul
Slieve Mish Mt
Dunquin
(Dún Chaoin)
Ventry
(Ceann Trá)
Dingle
(Daingean
Uí Chúis)
Inch
Aughils Bri
The Blasket
Islands
Cromane
Dingle Bay
Killorgli
(Cill Orglar
Glenbeigh
Ballynakilly
Kells
Shanacashel
Cahersiveen
(Cathair Saidhbhín)
Teeromoyle
Knightstown
Lissatinnig Bridge
(Droichead Lios an tSonnaigh)
Valentia
Island
Kilb
Aghnagar
Bridge
Killeenleagh
(An Chillín Liath)
Derreendaragh
Portmage
Mastergeehy
(Máistir Gaoithe)
Saahig
Sneem
Tahilla
Ballinskelligs
(Baile an Sceilg)
Waterville
Parknasilla
Ardea
The Skelligs
Castlecove
Collorus
Laura
Kenmare River
Catherdaniel
(Cathair Dónall)
Ardgroom
Eyeries
Adrigo
Urhin
Curryglass
Derree
Castletownbere
Ballynakilla
Garinish
Allihies
Bere
Island
Rerrin
Cahermore
Dursey
Island
Kilcroh
Sheep's
Head
Ballyroon
Dunman

arrigaholt
Skattery Island
Kilrush (Cill Rois)
Knock
Labasheeda
the Shannon
Lakyle
Foynes
Patrickswell
Ballyneety
Tarbert
Glin
Loghill
Askeaton
Cappagh
Adare
Beal
Astee
Ballyhahill
Shanagolden
Fedamore
Ballybunion
(Baile an Bhuinneánaigh)
Ballylongford
Croom
(Cromadh)
Moyvane
Carrigkerry
Ardagh
Rathkeale (Ráth Caola)
Bruff
Athea
Ballingarry
Granagh
Newcastle West (An Caisléan Nua)
Kilmorna
Bruree
Listowel (Lios Tuathail)
Duagh
Kilmeedy
Ballyagran
Kilmallock (Cill Mocheallóg)
Causeway
Abbeyfeale
(Mainistir na Feile)
Strand
Ballinclogher
Charleville (An Ráth)
Kilflyn
Broadford
Milford
Abbeydorney
Lyracrumpane
Mullaghareirk Mts
Dromina
Newtown
(An Baile Nua)
Reanagowan
Mountcollins
TRALEE (TRÁ LÍ)
Rockchapel
Meelin
Churchtown
Castleisland (Oileán Ciarraí)
Cordal
Newmarket
(Áth Trasna)
Liscarroll
Buttevant
Castlemaine
Scartaglin
Kishkeam
Kanturk
(Ceann Toirc)
Ballyclough
Doneraile
Milltown
Listry
Gneevgullia
Boherbue
Banteer
Mallow (Mala)
Beaufort
Rathmore
Dernagree
Drommahane
gobnet
Killarney (Cill Airne)
Drom
Nad
Burnfort
Caherbarnagh
Millstreet (Sráid an Mhuilinn)
Rathduff
Carriganima
Rylane
Donoughmore
Ballyvourney
(Baile Bhuirne)
Aghabullogue
Blarney (An Bhlarna)
Morley's Bridge
Macroom (Maigh Chromtha)
Tower
Kenmare
(Neidín)
Coachford
CORK (CORCAIGH)
Templenoe
Ballingeary
(Béal Átha an Ghaorthaidh)
Ovens
Aherla
hart
Killabunane
Inchigeelagh
Kilmurry
Crookstown
Bonane
Gougane Barra
Kilmichael
Cappeen
Cross Barry
Shanlaragh
Togher
Castletown
Bandon (Droichead na Bandan)
Belgooly
Glengarriff
Snave Bridge
Dunmanway
(Dún Mánmhaí)
Enniskean
Kilcolman
Kinsale (Cionn tSáile)
Trafrask
Ballylickey
Ballynacarriga
Ballinspittle
Bantry (Beantraí)
Ballingurteen
Kilbrittain
Garretstown
Gerahies
Drimoleague
Clonakilty (Cloich na Coillte)
Timoleague
Courtmacsherry
Lispatrick
Ahakista
Durrus
Derreeny Bridge
Drinagh
Reanascreena
Connonagh
Lisavaird
Butlerstown
Ballydehob
Skibbereen (An Sciobairín)
Leap
Rosscarbery
Castlefreke
Ardfield
Dunmanus
Unionhall
Rineen
Glandore
Schull
Creagh
Castletownshend
Galley Head
Whiddy Island
Bantry Bay

EAT & STAY
€€€ Eccles Hotel

The Eccles is one of the great hotels of Ireland. In its early days it was a staging post on the popular Prince of Wales' tourist route and it has seen many eras of Irish travel, from the hand-carried carriages that were walked across Priest's Leap (too sheer for horses), to the flying plane that actress Maureen O'Hara arrived in, and parked in the bay out front; the Eccles has earned its place in history. It is a charm the management team is building on, updating standards, creating event days, working hard to re-establish a hotel that remains a beacon of West Cork hospitality. *Glengarriff Harbour, Co Cork, eccleshotel.com +353 27 63003.*

EAT & STAY
€€€ Beara Coast Hotel

Head chef Mark Johnston and manager Mark Golden have brought the Beara Coast Hotel to deserved prominence in recent times, offering excellent food – monkfish with squid ink risotto and dillisk crisps; Beara Coast seafood burger; assiette of Beara seafood – and comfortable rooms. An excellent tasting menu offers the produce of the peninsula in vivid and imaginative creations, and the BCH is a vital destination in Castletown. *Cametringane Point, Castletownbere, Co Cork, bearacoast.com +353 27 71446.*

EAT
€€ McCarthy's Bar

McCarthy's was a famous pub long before the late Pete McCarthy's delightful book, *McCarthy's Bar,* declared that it 'might just be the best pub in the world'. Charming, comforting, convivial, it's the epicentre of Castletownbere, and an iconic part of West Cork and the Beara Peninsula. If you get the chance, do ask Adrienne to tell you about the wartime service of her dad, Aidan: it's an unbelievable story, and one that was made into the documentary film, *A Doctor's Sword. The Square, Castletownbere, Co Cork +353 27 70014. Open lunch & dinner.*

EAT Murphy's Mobile Catering & Dursey Deli

€ The Murphy family's Dursey Deli may very well be at the end of the world – well, the end of Europe, anyhow – but that doesn't deter food lovers from hopping in the car to drive all the way down the Beara Peninsula just to enjoy the fresh fish cooked by these talented street food masters. The fish is caught at the pier, most usually haddock, monkfish and whiting, and cooked in the van and served with crisp, dry chips, and it all adds up to a sublime eating experience at the edge of the world. Indeed, the Dursey Deli experience is so singular that it's commonplace for people to say that this is the best place to enjoy fresh fish and chips, anywhere. *Dursey Sound and Allihies Village, Co Cork @Murphy'sMobileCatering +353 86 3662865. Open daytime.*

EAT The Bistro

€€ Eyeries is an eye-wipingly pretty village, and the Bistro is where everyone heads to for squash ravioli with sage butter, steak and Guinness pie, and a good rhubarb crumble. There is a lovely garden out back for when the sun is shining. *Eyeries, Beara, Co Cork, @TheBistroEyeries +353 27 74885. Open dinner. Seasonal.*

Local Speciality – Knockatee Dairy

Sean Dempsey has a small portfolio of cheeses which he makes at Knockatee Dairy, using unpasteurised milk from a local herd when the herd is on the pasture. There is a Gouda-style cheese, which also comes with nettle and truffle flavourings. There is a mature strong cheddar, and the very fine Kerry Blue, one of the best blue cheeses in the country. Sean's cheeses are distinguished not only by their excellence, but also by the fact that they are probably the most difficult cheeses to actually source in Ireland. You can find them in good shops and restaurants in the West Cork and Kerry area, and sometimes in Cork city's English Market. Sean also rears beautiful pigs, whose meat is used by O'Sullivan's Butchers in Sneem: this is truly excellent, distinguished, precious pork.

Just Off The Way

At the scenic top-of-the-hill at **Moll's Gap,** 10km north of Kenmare, you find **Avoca** shop and café (avoca.com +35364 6634720) filled with excellent things to eat and buy. Nearby, Margaret and Peter Kerssens' delightful **The Strawberry Field**, (strawberryfield-ireland.com +35365 6682977) offers European-style pancakes, prepared from scratch, and delicately and expertly cooked and curated.

EAT Josie's Lakeview House Restaurant

€€ Just over the Cork/Kerry border, in a remote setting some 4km south of Lauragh, looking out across Glanmore Lake, Josie's offers good, simple cooking at lunch and dinner, and accommodation in an adjacent chalet. *Lauragh, Co Kerry, josiesrestaurant.ie +353 64 66 83155. Open daytime and dinner.*

EAT Teddy O'Sullivan's Bar

€€ On the cusp of Kilmackillogue Harbour, north of Derreen Garden on the R573, Teddy O'Sullivan's is rather confusingly known to locals as Helen's, most likely because the wonderful Helen has been running the show here for nigh on fifty years. You will see the diners sitting at the benches at the edge of the pier, having plates of mussels and pints of porter, and that's just what you should have too. *Kilmackillogue, Lauragh, Co Kerry, +353 64 66 83104. Open dinner and weekend lunch.*

EAT No 35

€€€ The *Irish Independent* described No 35's dish of home-made sausages with champ and onion jus as a "death row meal", a mighty accolade for something so simple. But behind the simplicity is exacting technique, and the pork for those sausages comes from pedigree saddleback pigs reared only a mile outside town. This care has seen No 35 ascend to Champion's League status. Lovely cloistering rooms, nice wines. *35 Main St, Kenmare, Co Kerry, no35kenmare.com +353 64 66 41559. Open dinner.*

EAT Maison Gourmet

€ Emma and Patrick know how to fashion a perfect millefeuille and how to bake a good sourdough, so it's no wonder that Maison Gourmet has a semi-permanent queue, both for those who want to sit and eat at the few tables, and for those who want to shop. Excellent staff speak French as they go about their busy day, bringing a true taste of la France profonde to pretty Kenmare. *26 Henry St, Kenmare, Co Kerry, @maisongourmet +353 64 66 41857. Open daytime.*

EAT Mulcahy's

€€€ Bruce Mulcahy has been a major player in Kenmare for more than two decades, and today his cooking shows the confidence and maturity won over that time, basking in fluent technique and relishing a seemingly effortless ability to nail every dish. The menus read straight-ahead – chicken; pork belly; risotto; fillet steak – but it is the kitchen's ability to make every iteration of these dishes memorable that has made the reputation of Mulcahy's. *Main St, Kenmare, Co Kerry, mulcahyskenmare.ie +353 64 66 42383. Open dinner.*

EAT The Mews

€€€ Tucked away in a courtyard just off Henry Street, The Mews is home to Gary Fitzgerald's signature style of classic cooking – vermouth cream chowder; ham hock terrine. Maria O'Sullivan's service is every bit as assured as the cooking. *3-4 Henry Court, Kenmare, Co Kerry, themewskenmare.com +353 64 66 42829. Open dinner.*

STAY Park Hotel

€€€€ An iconic destination in Kenmare, and indeed in Ireland, due to the TV fame of owners John and Francis Brennan. But, long before the crews came calling, the Brennan brothers were famed for the excellence of their service, and the classic style of the hotel. *Kenmare, parkkenmare.com +353 64 66 41200.*

EAT The Purple Heather

€€ Grainne O'Connell is one of the great food pioneers whose standards of excellence put Kenmare on the map. Her food and her welcome in the swaddling confines of The Purple Heather are as timeless as timeless gets, so sit back into a comfy red leather banquette and enjoy crab bisque with crab claws, or perfect prawn salad, and let the afternoon unfurl in a cocoon of pleasure. *Henry St, Kenmare, Co Kerry, thepurpleheatherkenmare.com +353 64 66 41016. Open lunch.*

STAY Shelburne Lodge

€€€ Maura Foley is a legend in the town of Kenmare, a pioneering restaurateur who opened her first shop way back in 1961. She opened Shelburne Lodge when she stepped back from the restaurant business, and quickly showed that she was also a brilliant interior designer and hostess. Shelburne is one of the most beautiful houses in Ireland. *Kenmare, Co Kerry +353 64 664 1013.*

EAT & STAY Brook Lane Hotel

€€€ Una and Dermot Brennan's boutique hotel, just at the edge of town on the road to the Ring of Kerry, is one of the best small hotels in the country, the sort of place where the staff truly care that what they do will make staying here special for the customer. The Brook Lane breakfast, in particular, is amongst the finest in Ireland, a tribute to superb pork ingredients reared by Dermot Brennan, whilst the cooking in Casey's Bar is excellent. *Sneem Rd, Kenmare, Co Kerry, brooklanehotel.com +353 64 66 42077.*

Local Speciality – Lorge's Chocolate

Benoit Lorge's neat little chocolate shop showcases the chocolates he produces at his outlet at the old post office in Bonane, a few miles south on the road to Glengarriff. The chocolates are super, and the chocolate making courses M. Lorge runs are mighty fun. *N71, Bonane, Co Kerry, lorge.ie +353 64 66 79994.*

EAT ### Quinlan's Seafood Bar

€€ Quinlan's is both a takeaway and a sit-down restaurant, but the excellence of their fish cooking is best enjoyed by grabbing a table upstairs and taking your time to enjoy Portmagee crab claws with garlic butter, or tempura of Atlantic prawns, or wild haddock with tartare sauce. With fish from their own small fleet, and expert attention to detail when it comes to important matters such as the quality of the chips, they know how to hit the spot. *30 Main St, Kenmare, Co Kerry, kerryfish.com +353 64 66 79949. Open dinner from 4pm.*

EAT ### Boathouse Bistro at Dromquinna Manor

€€€ Some really fine seafood cooking in the Boathouse Bistro, set in the grounds of luxurious Dromquinna Manor, is a major draw for food lovers. Whilst there is a small selection of meat dishes, it is the fish and shellfish that should be your choice – crispy fish tacos; Atlantic scampi; Boathouse fishcakes; halibut with fresh lemon. The room is quite lovely – you will think you are in New England on Kenmare Bay – and the superb gin menu will give you more reason to linger as you look out on the waters. The glamping tents in the grounds are luxury defined. *Sneem Rd, Kenmare, Co Kerry, dromquinnamanor.com +353 64 66 42888. Open lunch & dinner.*

STAY ### Parknasilla

€€€ "It is part of our dream world" was how George Bernard Shaw described the spectacular Parknasilla. GBS was right: this is an enchanting place, a 500-acre ocean liner that embraces you from the moment you drive through the gates and swallows you up for the duration of your stay. Of course, the hotel has all the luxuries you associate with a top-class getaway, but it is distinguished above all by the sheer Kerry charm and affability of the staff: these guys know how to look after you properly. *Sneem, Co Kerry, parknasillaresort.com +353 64 66 75600.*

Local Speciality – Sneem Black Pudding

O'Sullivan's Butchers is a modest and quite wonderful butcher's shop in Sneem, at the start of the Ring of Kerry, where you will find benchmark Kerry-style black pudding, fab sausages, and some outstandingly fine rare-breed pork from local breeders. A real Kerry gem. *Sneem, Co Kerry, +353 64 66 45213.*

EAT Kelly's Bakery

€ The Kellys run a truly special place here, in the centre of the village, and they have been doing the good thing since 1955. They offer everything you need, whether it's an excellent breakfast or a double chocolate éclair, or all the elements of a truly special picnic, including the very-hard-to-find Derreenaclaurig Cheese, made on the Ring. *Sneem, Co Kerry, +353 64 66 45178. Open daytime.*

EAT & STAY Westcove Farmhouse

€ Turn off the main road between Castlecove and Caherdaniel, heading south, to find Jane Urquhart's fine bakery and craft shop and, if you are charmed by the location, then there is a self-catering apartment to rent. A cup of tea and an almond croissant, or a slice of one of Jane's fine cakes, sitting in the courtyard under the canopy, watching the myriad bird life, is rather delightful. *Castlecove, Co Kerry, westcove.net +353 87 2942138. Open daytime.*

EAT The Lobster

€€ Poached lobster with chips, salad and aioli is the stairway to heaven in the ever-buzzing The Lobster, a cosy, noisy bar and restaurant set on Waterville's main strip. John Doyle and his team serve scrummy, vivid, finger-licking food – nori-wrapped monkfish; home-cured beetroot salmon; beef and Guinness stew – and if you have to wait for a table, then it's worth the wait. *Main St, Waterville, Co Kerry, @thelobsterwaterville +353 66 947 4629. Open lunch and dinner. (See photo, opposite, bottom left).*

EAT & STAY €€€ Butler Arms Hotel

The Huggard sisters – Louise and Paula – are doing a mighty job in the family's Butler Arms Hotel, and have elevated it to one of the finest places to stay and eat in windy Waterville. It's a hotel where things are done right, where the staff are helpful, where the cooking is soulful and correct, and the entire experience is a joy. Chef Craig Newell's signature dish of scallops with parsnip purée, black pudding crumb and apple gel is a masterpiece and the fish cookery in Charlie's Restaurant is authoritative and delicious. *Waterville, Co Kerry, butlerarms.com +353 66 947 4144. Charlie's Restaurant open dinner. (See photos, opposite).*

EAT & STAY €€ The Smugglers Inn

The Hunt family's 13-bed hotel, on the coastline a mile from Waterville town, has been a mainstay of the Ring of Kerry for 40 years, offering comfortable rooms with darling views, a cosy bar, and a light-filled conservatory dining room where chef Henry Hunt offers finessed cooking of top-class ingredients – Dingle Bay prawns in kataifi pastry; plaice with cucumber wasabi; hake with basil pesto; pot-roasted short rib of beef with whipped potato. *Cliff Rd, Waterville, Co Kerry, smugglersinn.ie +353 66 947 4330.*

EAT € Ballinskelligs Chocolate

Colm Healy's chocolate metropolis has grown and grown over the years, and today it's one of the most bustling, fun places to visit on the WAW, and a place that kids will remember forever. It's a great, big open-plan space right at St Finian's Bay, where you get to taste a free sample of the chocolate, enjoy one of the several styles of hot chocolate drinks in their busy café, and then buy some bags of sweetness to take away to stoke the rest of your travels. *The Glen, Ballinskelligs, Co Kerry, skelligschocolate.com +353 66 947 9119. (See photo, page 66, top left).*

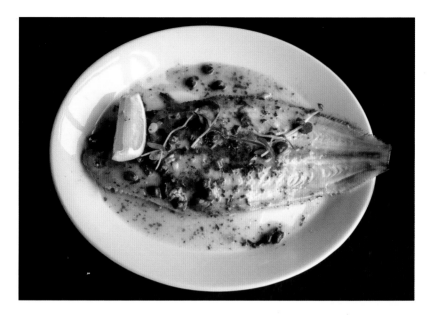

EAT **Valentia Ice Cream**

€ Joe and Caroline Daly's dairy farm and ice cream parlour is the essential stop on Valentia. The pedigree Friesian cows grazing in the field beside the shop produce the milk that goes to make these delicious ice creams, distinguished by their purity of flavour and lactic fullness. You won't find the ice cream anywhere other than at the parlour, so make sure to pull over as you drive along the R565. *Kilbeg East, Valentia Island, Co Kerry, @valentiaicecreamparlour +353 87 349 7385. Open daytime, seasonal.*

EAT **Pod**

€€ The gift shop/coffee shop is where you get the best cup of coffee in the town, along with some rather good crepes and ice cream. Coffee, crepes, ice cream, that will do nicely. *Market St, Knightstown, Valentia, Co Kerry, +353 66 947 6995. Open daytime, seasonal.*

EAT **The Coffee Dock**

€€ There is a rather fine terrace out front from The Coffee Dock, with views across the harbour that make it just perfect for soaking up the Valentia sunshine as you enjoy some scrambled eggs and coffee, or maybe a ham and cheese toastie. *Knightstown, Valentia, Co Kerry, @thecoffeedock +353 87 298 0199. Open daytime.*

EAT **O'Neill's The Point Bar**

€€ Directly adjacent to the ferry service crossing the water over to Knightstown, The Point is a treasure trove of good cooking, much prized by locals. You can't book, so turn up early to enjoy sublime seafood cookery – hake a la Romana; monkfish with garlic, potato, olive oil and chilli; lobster with crabmeat. They only serve seafood and, at the height of the season, the place will be jammers. *Renard Point, Cahersiveen, Co Kerry, oneillsthepoint.ie +353 66 947 2165. Open lunch & dinner, seasonally.*

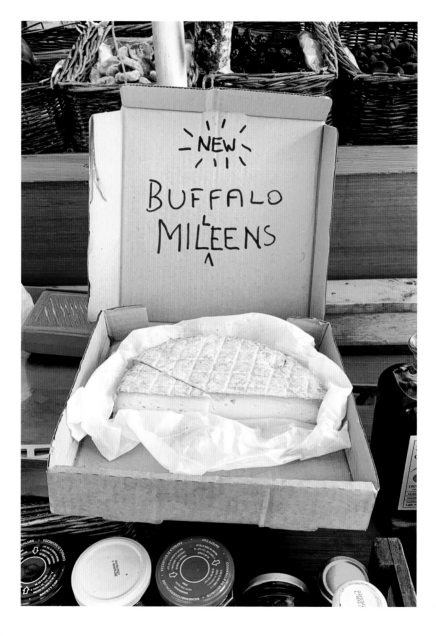

Just Off The Way

The town of Killarney is just off the Way...

The Killarney Park Hotel: the KP is not just the best hotel in Killarney town, it is one of the best hotels in Ireland. (*killarneyparkhotel.ie*)

The Ross: a super-stylish boutique hotel with a particularly winning design palette, from the same dynamic family who run the Killarney Park. (*theross.ie*)

Killeen House Hotel: just outside town, and worth the trip for legendary hospitality from owners Michael and Geraldine. (*killeenhousehotel.com*)

Muckross Park Hotel: across from the Abbey, the hotel is distinguished by some really fine cooking in the restaurant. (*muckrosspark.com*)

The Lake Hotel: the Lake has long been a favourite Killarney destination for many travellers. The location and vistas are simply breathtaking. (*lakehotelkillarney.com*)

The Europe: the public rooms and bedrooms, and the pool and spa, are amongst the best you will find anywhere in Europe. (*theeurope.com*)

The Brehon: a handsome and professional destination adjacent to the INEC concert venue. (*thebrehon.com*)

Celtic Whiskey Bar & Larder: not just whiskeys galore, but gins galore as well, and some good cooking from the Larder. Their excellent Whiskey Experience will make you an authoritative expert on the quixotic water of life in double-quick time. (*celticwhiskeybar.com*)

EAT The Oratory

€€ Pizza and wine in an old Gothic revival Church of Ireland built in 1865 seems to be the new path to salvation, especially if you have a quorum of kids who all want Pizza Bambini. For the adults there are the classic Margherita and Florentine, as well as funky riffs like the Blue Peach – Cashel Blue cheese and sliced peaches. Lovely wines. *West Main Street, Cahersiveen, Co Kerry, theoratorywinebar.com +353 66 948 1670. Open dinner.*

EAT & STAY Quinlan & Cooke

€€€ There are no other rooms quite like these stylish boltholes on the Ring of Kerry. Kate Cooke has created 10 rooms blessed with vivid and colourful modernist style, and one of them even includes a Pacman arcade machine. Breakfast is a delight, shared in the room and with fresh bread delivered to the bedroom door, there is smoked salmon, fresh fruit, good tea and coffee, and it makes for a lovely, lazy, private start to the day. With fresh wild seafood coming straight from their own boats, QC's Restaurant at Quinlan & Cooke offers some of the best seafood cookery you can find. This is a restaurant that can take an old cordon bleu standard, such as paupiettes of black sole stuffed with prawns, crab and spinach and make it seem like the very essence of the sea and of modern culinary arts. Classic, consistent and informal. *Cahersiveen, Co Kerry, www.qc.ie +353 66 947 2244. QC's Restaurant open evenings.*

EAT Petit Delice

€ The original Ring of Kerry outpost of the Killarney patisserie and eatery, Petit Delice has been an invaluable stop for Parisian-style cakes, dark-roasted coffee and well-executed savoury treats for more than a decade. David Aranda and his team are consistent and professional and the bricolage style of the room is ageless. *Main St, Cahersiveen, Co Kerry, +353 87 990 3572. Open daytime.*

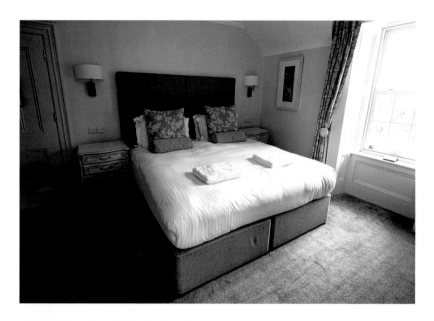

EAT O'Sullivan's Wine Shop
€ Willie's Atlantic Wines and Whiskeys wine shop has great wines, but above all it has a treasure trove of great Irish whiskeys and gins from the new generation of Irish distillers – if it comes from a copper still or has aged in a sherry barrel, then you will find it here. *30 Church St, Cahersiveen, Co Kerry, +353 66 947 2043.*

EAT Greek on the Street
€€ The owners may hail from Poland, but their touch with Greek seasonings and sensibilities means the food eats authentic, so you get a chance to escape to the Peloponnese whilst being on the Ring. BYO means it's inexpensive to eat good souvlaki, pork yeeros, Greek sausage, and there is even feta cheese to go with the good skinny fries. *21 Church St, Cahersiveen, Co Kerry, @greekcahersiveen +353 66 940 1010. Open lunch & dinner.*

EAT & STAY Kells Bay Gardens
€€€ Turn off the N70, head down the hill towards Kells Bay, drive through the gates of Billy and Penn Alexander's Kells Bay Gardens, and you are suddenly in a tropical world of palms, tree ferns, Thai cooking, rope bridges, and dinosaurs. At any moment as you explore the 8km of gardens, you expect a movie director to shout "Cut!" and reveal the entire thing to be an elaborate make-believe. But it isn't, it's all real, and when you add in the comfort of the country-house-style rooms, Kells Bay is someplace special. *Kells, Co Kerry, kellsbay.ie +353 66 947 7975. Open lunch & dinner.*

EAT Jack's Coastguard Restaurant
€€ An old coastguard station flung far out into Castlemaine Harbour, and overlooking Inch Point, Jack's is a sure-fire sender of great seafood cooking, and is a prized wedding destination on the peninsula. *Cromane, Killorglin, Co Kerry, jackscromane.com +353 66 976 9102. Open dinner & Sun lunch.*

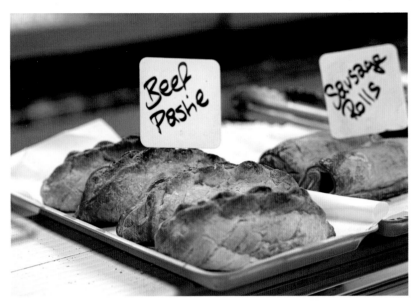

EAT **Jack's Bakery & Deli**

€ Jack's is one of the best shops in Ireland and, if you are gathering a picnic as you travel the Ring, then you will find everything you need right here. Jack's breads and sweet baking are masterly, the staff are motherly, and Jack and Celine power this mighty emporium with smiles and hard work. Everything you need is right here. *Unmissable. Lwr Bridge St, Killorglin, Co Kerry, @jacksbakery +353 66 976 1132. Open daytime.*

EAT **Sol y Sombra**

€€ Cliodna Foley was the first person to explore the symmetry of serving creative cooking in a deconsecrated church in County Kerry, and her initiative was inspired. Ms Foley pairs Spanish-accented flavours and tapas techniques with Irish ingredients, so Killorglin beef cheek is braised in Rioja, baby squid are marinated in buttermilk and served with a seaweed mayo, whilst chorizo is cooked in Cronin's cider and served with caramelised onions. Trade between Northern Spain and the south coast of Ireland was profuse during the Middle Ages, as sailors used the sea routes between the Celtic countries, and Ms Foley has brought that shared culture together superbly. *The Old Church of Ireland, Killorglin, Co Kerry, solysombra.ie +353 66 976 2347. Open dinner.*

EAT **Zest**

€ Zest is the classy and energised room where the good folk of Killorglin meet up with each other to enjoy the spirited cooking and service of Nicola Foley and her hard-working team. Right from the excellence of that early-morning scone and jam with a good cup of coffee, then through the healthful and hip collation offered through the day – Thai beef salad; Zest club sandwich; bagel with goat's cheese and roasted peppers – this is cooking that always hits the spot. *School Rd, Killorglin, Co Kerry, zestcafe.ie +353 66 979 0303. Open daytime.*

EAT **Bob's Coffee**
€ Bob has the patience and the expertise to make the most of the good beans he sources from Dublin's prized 3fe roasters, so this is the purest caffeine hit in the zone. Simple room, simple savoury and sweet things, superb coffee. *4 Iveragh Rd, Killorglin, Co Kerry, @bobscoffeeshopkillorglin. Open daytime.*

EAT **Giovanelli**
€€€ If you should be seized by the need to enjoy some authentic Italian cooking when travelling the WAW, then you are in luck. Giovanelli is right here in the centre of town, offering beef ravioli with butter and sage; gnocchi with gorgonzola and swiss chard; and Kerry lamb with polenta rustica. Nice to see that the black sole alla mugnaia comes with veg and spuds. *Lwr Bridge St, Killorglin, Co Kerry, giovannellires-taurant.com +353 87 1231353. Open dinner.*

EAT **Quinlan's Seafood Bars**
€€ The local Kerry seafood heroes have a small counter inside the fish shop in the centre of town where they fry up excellent fish and chips and fresh seafood. There are several good Quinlan Seafood bars in different locations in Kerry and Cork, and they also operate a series of fish shops, where their fresh crab, in particular, is highly prized by local chefs. *The Square, Killorglin, Co Kerry, kerryfish.com +353 66 976 1860. Open lunch & dinner. Other branches: 77 High St, Killarney, +353 64 662 0666; 21 Plunkett St, Killarney +353 64 662 3597; The Mall, Tralee, +353 66 712 3998; 14 Princes St, Cork +353 21 241 8222; and 30 Main St, Kenmare +252 64 667 9949.*

EAT **Milltown Organic Store**
€ Just on the edge of the village, Mary O'Riordan's shop is a tabernacle, and a joyful place to find all sorts of crazy, wonderful foods. From wholefoods to wine, to garden equipment. Find it here. *Castle-maine Rd, Milltown, Co Kerry, milltownorganicstore.com +353 66 976 7869. Open daytime.*

EAT& STAY The Phoenix

€€ Lorna Tyther's much-loved vegetarian restaurant is one of the signature destinations of the Dingle peninsula, and their grounds also offer two Romany wagons, which sleep two (with or without kids) and there is a field in which to pitch a tent. Bathrooms in the house, where there are also some rooms for B&B. Lorna wrote an excellent cookery book, *A Culinary Adventure*, a few years back, so make sure to get a copy to bring her fine vegetarian recipes home with you. *Shanahill East, Castlemaine, Co Kerry, thephoenixrestaurant.ie +353 66 976 6284. Open daytime.*

EAT Sailor's Catch

€ This is where the locals come for good fish, chips cooked in lard, and a pint of porter. There's also a takeaway. *Patcheen's Bar, Annascaul, Co Kerry +353 66 9767869.*

EAT & STAY Ashe's Bar

€€€ Ashe's is one of the classic Dingle pubs, and offers excellent seafood cooking in their restaurant. There are three rooms for lodgings upstairs – two doubles and a twin – and the location on Main St couldn't be better. *Main St, Dingle, Co Kerry, ashesbar.ie +353 66 9150989. Open lunch & dinner. Seasonal.*

Local Speciality – Annascaul Black Pudding

Great black puddings have a resonance in the Irish larder, and in the Irish culinary soul. And no other black pudding can match the resonance of Thomas Ashe's legendary Annascaul black pudding. The resonance is so deep, partly because of the pudding's vaunted history – it was first produced in 1916 and has been crafted by three generations of the family. But it's also partly because Thomas continues to make Annascaul pudding in the traditional Kerry style – cake-baked, made with fresh blood according to the original recipe. There are few other foods that can claim such ancestry and distinction in Ireland. *Main St, Annascaul, Co Kerry, annascaulblackpudding.com +353 85 1194749.*

EAT **Bácús Bhréanainn**

€ Orla Gowen is a terrific baker, and her sourdough breads are one of the great treats of Dingle. She has learnt her craft slowly and methodically, always upping her skill level, always acquiring a greater mastery of the mystery of sourdough. But don't overlook the sweet treats, and the lunchtime sandwiches are ace. *Green St, Dingle, Co Kerry, bacus.ie +353 87 318 5453.*

EAT **Bean in Dingle**

€ Justin and his crew have squared the circle by opening their own Bean in Dingle coffee roastery, with beans roasted by Katie Waldron, so you can pick up a smart yellow bag of their favourite coffee, and even order them online to get a fix of that Dingle magic. The team haven't put a foot wrong over the last five years: fine coffee; smart, zappy food, and a raucous atmosphere at all times of the day. *Green St, Dingle, Co Kerry, beanindingle.com +353 87 299 2831. Open daytime.*

EAT **The Chart House**

€€€ Owner Jim McCarthy stresses the "importance of sincere and meaningful hospitality", and his team deliver that for customers of this busy bistro. *The Mall, Dingle, Co Kerry, thecharthousedingle.com +353 66 915 2255. Open dinner. Seasonal.*

STAY **Castlewood House**

€€€ Surgical precision. That's what Brian Heaton brings to the breakfast table at Castlewood, the elegant lodgings he runs with his wife, Helen. Just look at that breakfast bap. Look carefully at the thin folded slices of bacon under the thin slices of tomato under the perfectly poached eggs under the perfectly executed hollandaise sauce. Surgical. Precise. Astounding. Breakfast in Castlewood is a performance, and Brian and Helen earn an Oscar every morning. *The Wood, Dingle, Co Kerry, castlewooddingle.com +353 66 915 2788. (See photo, opposite).*

Local Heroes – Dick Mack's Pub & Brewery

Dick Mack's is the most polyglot pub in Ireland and, on any given night, it seems that you can hear every imaginable language and accent from all over the globe, all coalescing into a raucous Esperanto as the evening wears on. The babble is fuelled by the fact that the drinks are so fine: this is one of the best whiskey bars in Ireland, and hauls in awards every year for the scope and depth of its whiskey selection. And it's not just the drams: in the yard out back, brewer Aussie Barrett and his team have concocted a range of artful and original beers at the Brewhouse, and whilst enjoying the beers in the bar is some sort of Kerry bliss, they also conduct splendid brewery tours and tastings. The result is that a visit to Dick Mack's Brewhouse has quickly become a must-visit in the town. *47 Green Street, Dingle, Co Kerry, dickmackspub.com +353 66 915 1787.*

EAT **Crinkle Stores**
€ Sarah Dolan's shop is petite, and pretty perfect. It looks good, it feels good, and everything Sarah offers is good, so expect to spend a whole lot of money on desirable foods, even if you just nipped in for an excellent coffee. A true tabernacle of good things. *Lower Green Street, Dingle, Co Kerry, +353 85 766 9251. Open daytime.*

STAY **Dingle Bay Hotel**
€€€ Right down on the harbour in the magical town of Dingle, this modest hotel with its friendly bar and music sessions is a heart-warming, friendly base, ideal if visiting for any of the town's festivals. *Strand St, Dingle, Co Kerry, dinglebayhotel.com +353 66 915 1231.*

STAY **Dingle Skellig Hotel**
€€€ At the entrance to town, the Skellig has fine new suites which are abidingly stylish, large and comfortable, and make for a great base when exploring the peninsula. It's only a pleasant stroll into town to enjoy breakfast, lunch and dinner. *Dingle, Co Kerry, dingleskellig.com +353 66 915 0200.*

EAT The Fish Box

€€ Patrick and Michael Flannery and their crew have combined deep expertise in seafood, both in the catching and in the cooking, and have given their skills a funky stage that has been a huge success story since they opened The Fish Box. 'We have the real stuff' is what they say in The Fish Box, and the real stuff is what they have for sure, and who wouldn't walk all the way to Dingle for pan-fried John Dory with garlic Maharees potatoes and a ratatouille of local vegetables. A Dingle star. *Green St, Dingle, Co Kerry, thefishboxdingle.com +353 87 052 6896. Open lunch & dinner. (See photos, page 85, bottom left and right).*

EAT Global Village

€€€ Martin Bealin is a major force in Dingle's culinary identity, and Global Village personifies the very best Kerry eating – Dingle Bay crab in a whiskey bisque; garden greens in a salad with Dingle Peninsula cheese; Dingle prawns with garden pak choi; rillette of beef cheek with smoked potato; Blasket Sound lobster with herb and garlic butter. A makeover has created a simpler, less formal room, and it works just perfectly. *Upper Main St, Dingle, Co Kerry, globalvillagedingle.com +353 66 915 2325. Open dinner.*

Local Hero – Little Cheese Shop

Local food hero Mark Murphy is a dynamic guy, so as well as running one of the best shops in Ireland, he also teams up with Dick Mack's Brewery to organise Beer & Cheese tours, a great way for food lovers to get a handle on local speciality foods. Mark also puts together picnic baskets for travellers heading off for a tour of the Blasket Islands, so order one of these even if you only plan to tour the peninsula. This is a truly inspiring destination. *Grey's Lane, Dingle, Co Kerry @The LittleCheeseShop +353 87 757 8672.*

STAY **Greenmount House**

€€€ The Curran family's Greenmount House is synonymous with hospitality in Dingle, and has been a welcoming home-from-home for visitors for more than 40 years. You need to bring on the superlatives to describe their work, from the blissful comfort of the rooms to the stunning quality of the food they offer at breakfast and during the day. Everything is done with charm, and sweet sincerity. *Upr John St, Dingle, Co Kerry, greenmounthouse.ie +353 66 915 1414.*

EAT **Grey's Lane Bistro**

€€€ With their move to larger premises, Ed and Laurence are open from breakfast through to dinner, and Ed's sure-fire, international style of cooking is in top gear, from the signature chowder to the excellent duck confit. *Grey's Lane, Dingle, Co Kerry, greyslanebistro.com +353 66 915 2770. Open daytime & dinner.*

STAY **Heatons Guesthouse**

€€€ Cameron, Nuala and David Heaton seem able to read their guests' minds, so you will have scarcely made a request for something or other before they have it sorted. Their hospitality is only mighty, and the water's edge location, down near the Dingle Distillery, is perfect. *The Wood, Dingle, Co Kerry, heatonsdingle.com +353 66 915 2288.*

EAT **Land to Sea**

€€€ Julian Wyatt's restaurant quickly made an impact in Dingle, largely because here is a chef who relishes the sheer hard work of the kitchen, making his own brawn – served with dandelion salad and black mustard – or crafting a delicate ravioli of Dingle goat's cheese, which he pairs with caramelised pearl onions and basil pesto. Prices are very fair for such artful, explicit cooking, and who doesn't fancy some Crowe's farm pork cheeks, in Cronin's cider with pig's ear crackling. *Main St, Dingle, Co Kerry, landtoseadingle.com +353 66 915 2609. Open dinner.*

EAT **Murphys Ice Cream**
€ Kieran and Sean Murphy are amongst the greatest of Irish artisans, and their outstanding creativity has manifested itself in the production of the most sublime ice creams you can eat. No ingredient is safe from their madcap imaginations, so they do a cold extraction of Dingle gin to bring out the flavours; they enlist the superb Richmount elderflower cordial for the taste of early summer; they caramelise McCambridge's brown bread to bring the biscuit notes to the forefront; and they pan their own sea salt for the signature sea salt ice cream. Pure genius. *Strand St, Dingle, Co Kerry, murphysicecream.ie +353 66 915 2644. (See photo, page 85, top right).*

EAT **My Boy Blue**
€ Stephen Brennan and Amy O'Sullivan's My Boy Blue was a success from the moment they opened their doors, offering superbly curated coffee — their latte art is just amazing — and the sort of moreish food that brings people back to Holyground time after time: harissa eggs on sourdough; grilled goat's cheese with toasted walnuts; brioche brunch bap with crispy fried egg. Pure class. *Holyground, Dingle, Co Kerry, @myboybluedingle. Open daytime.*

EAT **Out Of The Blue**
€€€ Out Of The Blue could also be called "In The Moment" because the logic of owner Tim Mason's inspiring restaurant is to cook the catch of the day sourced from the local fishing boats, and nothing else. So what you get is the freshest seafood imaginable, cooked with improvisatory urgency by a really fired-up kitchen: the signature pollock in a potato crust; langoustines flambéed with pastis; John Dory with cheesy polenta. The wines are especially notable, and pair magically with the seafood. OOTB is the waterside seafood destination you were dreaming about. *Waterside, Dingle, Co Kerry, outoftheblue.ie +353 66 915 0811.*

EAT **The Pantrí Café**

€ The Pantrí is a tiny room on Main Street, but it is blessed with a big garden out back, and there is nowhere nicer to sit and enjoy their excellent food. Triona and Paul and the team source from the best artisans, and everything they make shows real care and focus – you won't get a better eggs Benedict anywhere else. Excellent natural wines give you even more reason to linger longtime in that lovely garden. *Lwr Main St, Dingle, Co Kerry, +353 86 103 2399. Open daytime. Seasonal.*

STAY **Pax House**

€€ John O'Farrell's Pax House is situated on the top of a hill, and the view enables guests to appreciate the stunning Dingle peninsula, so we recommend you request a sea view room to watch the sunrise over the bay. There is much to love about what John and his team bring to Pax House: butter balls on the breakfast table, on a silver leaf platter; the signature omelette made with cream cheese, camembert, tomato, seaweed and smoked salmon; the art works and the shell collection, all combine to make Pax someplace special. *Upr John St, Dingle, Co Kerry, pax-house.com +353 66 915 1518.*

EAT **Reel Dingle Fish and Chips**

€ Do Mark Grealy and his team make the best fish and chips in Ireland? Of course, everyone in Dingle says yes but, just as importantly, a substantial cohort of the rest of the Irish population also reckon that Reel Dingle fish and chips are the tops, which is why this tiny, narrow room always has a lengthy queue snaking out the door. Locally caught wild fish and superlative chips are the backbone of the offer, chalked on the blackboard, but excellent West Kerry burgers and sausages from the local butcher are of the same benchmark quality. So, join the queue and get the superlatives ready. *Bridge St, Dingle, Co Kerry reeldinglefish.com +353 66 915 1713. Open lunch & dinner.*

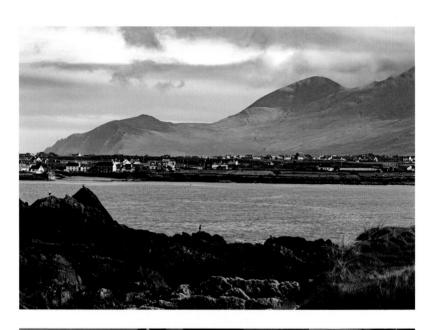

EAT **Solas**

€€€ Nowhere does small plates better than Solas. Owners Ann Connell and Nicky Foley pay some homage to the Spanish roots of the dishes, so you can order monkfish with romesco, or jamon with mustard fruits. But it's their own creations that really fly, especially the seafood chowder croquette, the pork belly with toffee apple parsnip purée, and the Dingle gin marinated fennel with ricotta. Ann and her team have that hard-working Dingle ethos, and it's a great room. *Strand St, Dingle, Co Kerry, solastapas. com +353 66 915 0766. Open for dinner from 5pm. (See photo, page 85, top left).*

EAT **Caifé na Caolóige**

€ The light-filled rooms in the shop and the Caifé offer the gorgeous pottery that has made Louis Mulcahy's work world-famous. So, first you admire the plates, cups and vases and amphorae, and then you pick something delicious in the Caifé, and eat and drink using the glorious pottery. But what makes the Caifé special is the beauty – and deliciousness – of every plate that Emer and her team create. This is a don't-miss! destination on Slea Head. *Louis Mulcahy Pottery, Clogher Strand, Ballyferriter, Slea Head, Co Kerry, louismulcahy.com +353 66 915 6229. Open daytime.*

Local Speciality – The Dingle Distillery

The Dingle Distillery was the trailblazer in Ireland's renaissance of craft distilleries, and the first to bottle their own single malt, which was also the first to be made in Ireland in 25 years. Triple distillation, maturation in bourbon, sherry and port casks, and those agile, vivid Dingle winds and cloistering misty mornings close to the edge of Dingle Bay all make for an utterly distinctive single malt. There are also excellent gins and vodkas, and the tours of the distillery are pure fun. *Dingle, Co Kerry, dingledistillery.ie +353 66 402 9011.*

EAT & STAY **Bric's Brew Pub**

€€ Adrienne Heslin is a great brewer, and there is nothing nicer than a trip to the beach at Wine Strand, followed by a few bottles of Beal Ban dark ale in the atmospheric bar, the most south-westerly craft brewery in the country. Four rooms, which share a kitchen and living room, make for cosy accommodation. *Ballyferriter, Co Kerry, westkerrybrewery.ie. Open from 11am.*

EAT **Tigh T.P.**

€€ The views across Smerwick Harbour from the tables outside Tigh T.P. are to die for, and the views and the confident cooking – tempura-battered hake and chips; monkfish scampi; lobster roll – draw huge crowds during the season. *Ballydavid, Murreagh, Co Kerry, @TighT.P. +353 87 246 0507.*

EAT **Gregory's Garden**

€€€ Kerry Mountain lamb pizza from the Forge Wood Fired Pizza Oven shack in the garden of Gregory's Garden: does that ring your bell or what? But firing out rock steady pizzas from the Forge is only one aspect of the garden, for the main restaurant has some scintillating cooking, using ingredients grown right outside – smoked haddock arancini with pickled vegetables; lamb rump with wild garlic salsa verde. "The guy has a vision and clarity of mission," reported a friend, and you taste that vision and mission in every lovely bite. *Main St, Castlegregory, Co Kerry, gregorysgarden.ie +353 87 3213 0866. Open all day & dinner.*

EAT & STAY **Spillane's Bar & Restaurant**

€€ Michael Spillane's bar is a landmark in the Maharees area, home to spontaneous and organised music sessions and some good bar food. Booking advisable if you are going to travel. Two self-catering rental apartments are available next door, and Michael knows all about this region. *Fahamore, Castlegregory, Co Kerry, spillanesbar.com +353 66 713 9125.*

EAT **The Roast House**

€€ Ronan and Linda have their own on-site coffee roastery in the Roast House, set in the lovely terrace of Denny Street in the centre of town, so it's the place for that good cup of Java. But whilst the coffee may bring you in, the cooking will make you linger, especially for their trio of burgers which offers pitch-perfect examples of burger architecture, and which have won much-deserved acclaim. It's a lovely friendly room. *3 Denny St, Tralee, Co Kerry, theroasthouse.ie +353 66 718 1011. Open daytime.*

EAT **Croi**

€€€ Noel, Paul and Kevin make up the trio behind the ambitious Croi: Noel in the engine room, with Kevin at front of house, whilst Paul cooks in their nearby Gra Bistro. Their dedicated local sourcing signalled their ambitions, and their intent: Croi means "the essence of" and the essence of contemporary Irish cooking is what they are chasing. They have gathered in all the great local artisan produce, including rarities such as local wasabi, 100-day beef aged in honey cappings, Max's mozzarella, Annascaul black pudding, and the plates sing with local pride: Fenit crab with cucumber gazpacho; chuck steak with Croi butter; cauliflower steak with coastal greens. Excellent value, good wines. *14 Princes St, Tralee, Co Kerry, croirestaurant.com +353 66 712 0685. Open dinner.*

EAT **Spa Seafoods**

€€ Spa Seafoods is worth the short detour out of Tralee, as you head down the road towards Fenit, to eat some of the tastiest seafood cookery in this part of north Kerry. Upstairs is a handsome room which also offers some of the most entrancing views out over the Dingle peninsula, and delicious seafood cookery: in particular, don't miss the oysters with trout caviar. *The Spa, Tralee, Co Kerry, spaseafoods. com +353 66 713 6901. Open dinner Tue-Sun, lunch Fri-Sun.*

The Western Islands of the Wild Atlantic Way

Garinish Island

The famous island garden of Ilnacullin is situated on Garinish Island, in Glengarriff harbour in Bantry Bay. The island garden now belongs to the Irish state and is a bucket list adventure for many a garden enthusiast, locally and internationally. The garden is open 7 days a week, Apr-Oct. Be prepared to pay twice, once to the ferry operator, and then again to enter the garden. There are café and toilet facilities on the island. Boats take the trip via Seal Island to see the languishing seals. The Blue Pool where the boats leave to take you to the island is a popular swimming spot.

Ilnacullin

heritageireland.ie

Garinish Island Ferry & Blue Pool Ferry harbourqueenferry.com & bluepoolferry.com

Bere Island

Its strategic site at the end of Bantry Bay has made Bere Island an important military base, and it has been used by both the British and the Irish army: indeed to this day it is still used for training exercises. A number of restaurants have come and gone on the island, but none seem to survive. So if you're going for the wedge graves, the birds, the angling, swimming or cycling, don't forget to bring a picnic.

www.bereisland.net

Dursey Island

Dursey is a small, inhabited island at the far, far, far West of the Beara Peninsula. The island is only approachable by the cable car which has been running precipitously over Dursey Sound since 1969. It runs continually back and forth between the hours of 9.30am-11am, 2.30pm-5pm and returning only from 7pm to 8pm. Because of the high volume of traffic it is recommended to go early and come back early. The experience of travelling over the sea will make your fingers and toes sweat. The bird population of Dursey – one of the main reasons for visiting – is made up of resident seabirds, shearwaters, guillemots, razorbills and puffins, and also, during the migration season it serves as a resting point for migrant birds. There is a loop walk around the island that you wouldn't want to undertake without a pair of binoculars around your neck.

durseyisland.ie

Skellig Islands

Visiting the UNESCO World Heritage Skelligs is an unpredictable journey given its westerly island location. But, if you do make it across in the boat with your dozen or so companions, then you witness the fruits of the extraordinary determination of the monastic mind: just how did the monks build the Monastery, the Oratory, St

Michael's Church, and the incredible beehive-shaped, corbelled dwelling cells, and how on earth did they manage to survive here for centuries. Before you go, call in to the Skellig Experience Visitor Centre to help understand the magic. Or simply enjoy the Skelligs on dry land.
Valentia Island, skelligexperience.com

The Blasket Islands

You can take a day trip to the Blasket Islands via Blasket Island Ferries. With luck, you might see dolphins and whales and even orcas en route, and on the island you might spot wheatears, stonechats, pipits, black-backed gulls and terns. There are more than 17 different species of sea bird breeding on the islands, including Manx shearwaters and storm petrels.

The Blasket Centre is also located on the mainland, in Dunquin, telling the story of life on the island. Blasket Islands Eco Marine Tours, based in Dingle, offer boat tours on the MV Blasket Princess with skipper Mick Sheerin. Tra Ban beach is considered to be one of the best beaches in Ireland. Dunquin Harbour itself is a spectacular drive, winding down the mountain face to the harbour.
The Blasket Centre, blasket.ie
Blasket Island Ferries
blasketisland.com

Scattery Island

A day trip to Scattery Island is much recommended to see the monastic settlement, which was founded in the 6thC, by local saint St Senan. There are actually the ruins of no less than six churches on the island and one of the highest round towers in the country – a lofty 120ft high. The island history is full of invasions and reclamations. Brian Boru recaptured the island from the Vikings. Situated at the mouth of the River Shannon, this is one of the best places to spot dolphins. Boat trips to the island depart from Kilrush marina daily during the summer. There is a small visitors' centre for those looking for a deeper knowledge of the island.
Scattery Island Visitor Centre
@scatteryislandvisitorcentre

Ballinaboy

Doonloughan

Toombeola

Maam Cross

Ballyconneely

Cashel

Gortmore
(An Gort M

Roundstone

Glinsk
(Glinsce)

Rosmuck
(Ros Muc)

Ard
(An Aird)

Kilkieran
(Cill Chiaráin)

Carna

Costelloe
(Caslá)

Carraroe
(An Cheathrú
Rua)

Lettermullen
(Leitir Mealláin)

Kilmurvey

Kilronan
(Cill Rónáin)

Inis Mór

Aran Islands

Inis Meáin

Inis Oírr

Killard

Doonbeg

Kilkee
(Cill Chaoi)

Moya

Kilfearagh

Breaghva

Querrin

*Skatte
Islan*

Feeard

Cross

Carrigaholt

Kilbaha

Mouth of the Shannon

Beal

Aste

Ballybunion
(Baile an Bhuinneánaigh)

Ballyduff

Ballynaskreena

Dreenagh

Causeway

Listowe
(Lios Tuathai

Ballyheigue

Ballinclogher

The
Cliff
Coast

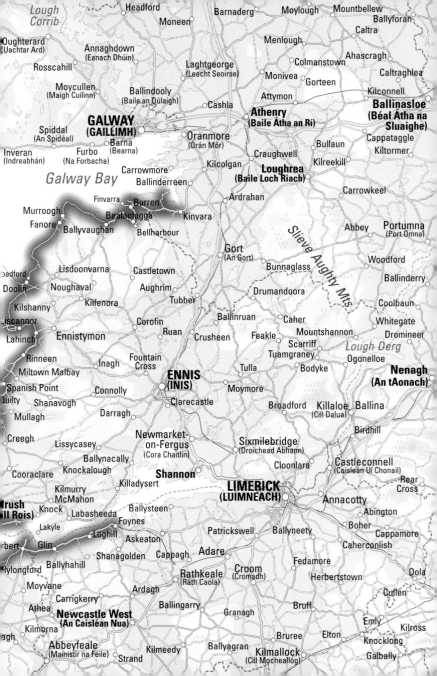

EAT
€€€
Daroka

Dan O'Brien is a total cook, a guy who understands his food from soup to nuts. He can cook anything, and bestow on it true authenticity, whether it's carrot risotto or spinach and ricotta ravioli or marmalade brioche bread pudding. His depthless skills are explained partly by the fact that he is a true countryman, alive to foraging and growing, but also to the fact that he is a fine musician, and he brings that musician's ability to improvise to everything he cooks: this is well-tempered cooking, from lamb neck with black kale to chocolate truffle cake with hot chocolate. Cosy rooms on two floors, and great value for money. *Cliff Rd, Ballybunion, Co Kerry, daroka.ie +353 68 27911.*

EAT & STAY
€€€
McMunn's

Greg and Una McMunn have been doing the good thing in their bar and restaurant with rooms in little Ballybunion for more than a decade. The cooking is straight-ahead tasty – oysters from the tank; seared scallops with Athea black pudding; Hereford beef sirloin; lobster thermidor. *Strandhill Rd, Ballybunion, Co Kerry, mcmunns.com +353 68 28845. Open lunch & dinner. Seasonal.*

EAT
€€
The Long Dock

Long before anyone ever talked about gastropubs, Tony and Imelda in The Long Dock were serving stellar cooking in one of the prettiest and most comfortable traditional pubs on the West Coast. The Long Dock is, then, the original gastropub, home to welcoming comfort and an always-lit fire, and home to cutting-edge cooking that showcases the best fish and shellfish of the region. Tony's chowder is the bowl of seafoody goodness from heaven, and the classic fish pie is deservedly famous. Great ice creams for pudding, and you will also find those ices for sale in their lovely Parlour shop. *Carrigaholt, Co Clare, thelongdock.com +353 65 905 8106. Open lunch & dinner.*

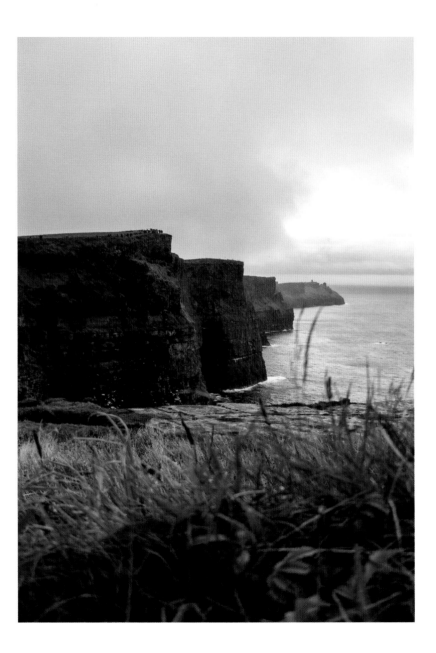

STAY **Old School House**
€€ Ian and Theresa brought a near-derelict old National School back to vibrant life when they restored the Old School House. Ian bakes delicious treats for breakfast, and it's the most delightful experience to enjoy them in the tall, light-filled classroom. Theresa is a guide at the Loop Head lighthouse and, between them, this duo knows everything about the region. *Cross, Carrigaholt, Co Clare, @theoldschoolBandB-cross +353 86 154 9402.*

STAY **Glencarrig B&B**
€€ Mary Aston is one of the best Irish bakers we know. Mrs Aston bakes in the Irish vernacular style, that sweetly-savoury style that blesses scones, cakes and pastries with a maternal signature – simple, precise, designed to please, not to astonish. The house is very comfortable, set in a beautiful part of beautiful Loop Head, and Luke Aston takes you fishing in his boat so, yes, there will be fresh mackerel for breakfast – Glencarrig is actually the accommodation side of Carrigaholt Sea Angling Centre. *Ramona, Carrigaholt, Co Clare, fishandstay. com +353 65 905 8209.*

EAT **BiaBaile @ Murphy Blacks**
€€€ Cillian and Mary simplified their offer in Murphy Blacks to make it more casual, but Mary's cooking still enjoys all the discipline and energy of a dedicated, creative chef, and her signature dishes – the legendary crab cakes; the monkfish scampi; the cannelloni of plaice; the Moroccan meatballs – are so special that you would walk to Kilkee to enjoy them. Cillian's service is witty and just right, and it's always a special place to visit. *The Square, Kilkee, Co Clare, murphyblacks.ie +353 65 905 6854. Open dinner.*

EAT **Diamond Rocks Café**
€ The views from the Diamond Rocks Café out over Kilkee Bay are stunning. Whilst it's a lovely stop-off

for refreshments as you walk the coastal path, it's also a fine destination in its own right. And do check out that groovy Richard Harris statue! *West End, Kilkee, Co Clare, diamondrockscafe.com +353 86 372 1063. Open daytime.*

EAT **Lir at Kilkee Golf Club**
€

Deirdre Daly is one of the best cooks and bakers working on the Wild Atlantic Way. Ms Daly could serve her food and her breads from a Nissen hut in the middle of an industrial estate, and we would flock to eat them. Fortunately, at her base in Kilkee, at the golf club, she gives us sublime cooking, along with some of the finest sea views on the WAW. Do look out for Deirdre's bread in the local shop, McNamara's, in Kilkee. *Kilkee, Co Clare, @liratkilkeegolfclub +353 65 9056048. Open daytime.*

EAT **Naughton's Bar & Restaurant**
€€€

There is some fine cooking in the atmospheric and interweaving series of rooms that is Naughton's. Robert and Elaine do things precisely and expertly, and the standards of cooking are high: West Clare crab claws; rib-eye with mushrooms. Naughton's is so successful that it's often impossible to get a table, either in the bars downstairs or in the beautiful rooms upstairs, so be prepared to wait if you don't have a reservation. *45 O'Curry St, Kilkee, Co Clare, naughtonsbar.com +353 65 905 6597. Open dinner.*

EAT **The Pantry Shop & Bakery**
€

The Pantry is the epicentre of Kilkee on a busy summer day, with everyone calling in to eat breakfast, buy Imelda's breads and her classic carrot cake, sit around over a lazy lunch of cottage pie or coronation chicken wrap, or relax and read the paper or browse the laptop over a cup of coffee. The Pantry has been an essential destination for nigh on forty years. *O'Curry St, Kilkee, Co Clare, thepantrykilkee. ie +353 65 905 6576. Open daytime.*

EAT & STAY
€€
Stella Maris

Ann Haugh's family hotel is a real charmer. Under-stated and old-school, it's the sort of place you might imagine had ceased to exist in contempo-rary Ireland, but here it is: welcoming, delightful, unpretentious and real. The family are fortunate to have their own butcher's shop, so it's a no-brainer to choose a black Angus fillet steak after you have enjoyed Carrigaholt mussels or Poulnasherry oysters. Just lovely. *O'Connell St, Kilkee, Co Clare, stellamarishotel.com +353 65 905 6455.*

EAT & STAY
€€
The Strand

Johnny Redmond's smashing cooking is reason enough to go to The Strand, but the views from the rooms in the guesthouse, out across the bay, are another good reason to make the most of this resort hotel. Four generations of the Redmond fam-ily have delivered serene hospitality to the people of Kilkee, and Johnny's cooking in their Bistro is spot on. Excellent rooms are of a much higher standard than one expects from a guesthouse. *Kilkee, Co Clare, thestrandkilkee.com +353 65 905 6177.*

STAY
€€
Thalassotherapy Centre Guest House

Eileen Mulcahy harvests the serrated wrack sea-weed she uses for her seaweed baths with her own hands, and then uses them to brew up the most sublime bath you have ever had. Book one of the five comfortable rooms upstairs, enjoy a delicious breakfast in the dining room, then plunge into that old porcelain bathtub for an hour, and you never felt so good in all your life. *Grattan St, Kilkee, Co Clare, kilkeethalasso.com +353 65 905 6742.*

Local Speciality – Considine's Bakery

Consider this: Considine's Bakery was established not long after the end of the Great Famine. 170 years later, their lovely loaves sustain the people of Kilrush. The staff of life, and how. *Francis St, Kilrush, Co Clare +353 65 905 1095.*

EAT & STAY
€€€ **Morrissey's Bar & Restaurant**

There are half a dozen clean and comfortable rooms for lodging in this classic Irish village pub, on the main street in Doonbeg. You can't actually book a table in Hugh Morrissey's popular bar and restaurant, so if you are planning a trip in high season, then go early at 6 o'clock, or go late. The cooking is very good – direct, tasty and suitable for all ages – and when the kids have finished they can scamper around the gardens at the river's edge. *Doonbeg, Co Clare, morrisseysdoonbeg.com +353 65 905 5304.*

EAT & STAY
€€€ **Armada Hotel & Johnny Burke's Pub**

With the fresh produce from their own Armada Farm going straight from the farm into the kitchen, chef Peter Jackson is able to ratchet the flavour dials up to 11 in the Burke family's superb hotel. The Pearl Restaurant is the centrepiece of dining in the hotel, with considered, elegant food – oysters with seaweed dashi; Armada beets with grilled baby gem; turbot with charred leeks and potato mousse. But there is also fine cooking in Johnny Burke's bar, not least the splendiferous Galleon, a tier of terrific tastes which is great value for money. Sea views from the bedrooms are enchanting. *Spanish Point, Co Clare, armadahotel.com +353 65 707 9000.*

STAY
€€€ **Red Cliff Lodge**

Christopher and Eimear's handsome mixture of cottage-style suites, and a pretty restaurant, at Spanish Point, allows the couple to showcase their skills. Christopher celebrates the local foods – Moyasta oysters; St Tola goat's cheese; Noel O'Connor's meats and game; Burren Smokehouse salmon – in elegant dishes: fishcake with seaweed mayonnaise; Burren smoked salmon with crabmeat and tartare cream; rhubarb and vanilla brûlée with ice cream sandwich. The dining room is charming, the suites are large and super-comfortable, and this is a lovely get-away. *Spanish Point, Co Clare, redclifflodge.ie +353 65 708 5756.*

STAY **Moy House**

€€€ Perfect meals are rare things, but Matt Strefford is one of those chefs who can do perfect. His cooking, in the elegant luxury of Moy House, is helped enormously by the fact that he rears his own animals, and grows his own vegetables with his gardener, Sarah Noonan. His technical prowess, then, brings home the bacon, and whilst the menus read straight-ahead – cauliflower velouté; hake with garden vegetable risotto; Moy House Dexter beef with onion purée – Mr Strefford's flair makes for unforgettable eating. Lovely rooms, and breakfast is one of the best in Ireland. *Lahinch, Co Clare, moy-house.com +353 65 708 2800.*

EAT **Randaddy's**

€€ A big room that is part of the big Beach Front in Lahinch is home to Randy Lewis' eclectic and well-handled cookery. If you have been out on the waves, Mr Lewis has some punchy, creative cooking that will put the fire back into your battered body. Mr Lewis has been all around the world, and he has learnt at every stage of his journeys, so the international dishes are handled with sympathy and understanding. Good value and excellent service bring it all home safely. *The Prom, Lahinch, Co Clare, randaddys.ie +353 65 708 2740. Open daytime & early dinner.*

EAT **Hugo's Deli**

€ "Bravo Hugo" wrote Darina Allen, after enjoying "one of the best pasteis de nata I've ever eaten." Our friend Valentina relished "a full square metre of top class schiacciata done with Molino Grassi flour! Amazing stuff. I gorged it, hot just out of the oven." People, Hugo Galloway's baking is a shining star, all the more so because Mr Galloway is self-taught, yet he can bake a sourdough like someone from California and make a Portuguese custard tart like someone who just arrived from Belém. *Lahinch, @HugosDeliLahinch +353 87 977 6391. Open daytime.*

EAT & STAY
Vaughan Lodge

€€€ Just up the hill from the golf links, Michael Vaughan's smart, modern hotel is the ideal stage for the boss to show how he is one of the great Irish hoteliers. Blessed with bounteous energy, Mr Vaughan is one of the great hosts, and he knows what you need even before you do. Every year, he raises standards throughout the hotel, not least in the VL restaurant, where the cooking is very fine indeed: scallops with roasted almond cream; fillet of beef with onion spaghetti; triple chocolate dome. A WAW classic. *Ennistymon Rd, Lahinch, Co Clare, vaughanlodge.ie +353 65 708 1111. Open dinner.*

EAT & STAY
Vaughan's Anchor Inn

€€€ Whilst most people travel to Vaughan's in Liscannor to enjoy Denis Vaughan's ambitious, cheffy food, travellers should note that they also offer three fine en suite rooms, including a family room, above the restaurant and bar for guests. The cooking in the restaurant is mighty: there aren't too many Irish pubs where they offer home-made black pudding with foie gras, or 21-day chateaubriand, or langoustine crumble, and it's a charming room. The pub itself is classic old-school, and delightful. *Main St, Liscannor, Co Clare, vaughans.ie +353 65 708 1548. Open lunch & dinner.*

EAT & STAY
Hotel Doolin

€€€ Hotel Doolin is distinct and different. There is a true sense of creativity about how the team here carry out their work, and it means that they avoid the clichés that make so many hotels humdrum. It's a destination where all the while they are hosting craft beer festivals, writing festivals, music festivals, so stay here and catch that energy. The cooking uses many elements from their garden, served in the Chervil Restaurant, the Stone Wall Café and Pizzeria; and grab a drink in Fitz's Pub where there is live traditional music. *Ballyvoe, Doolin, Co Clare, hoteldoolin.ie +353 65 707 4111.*

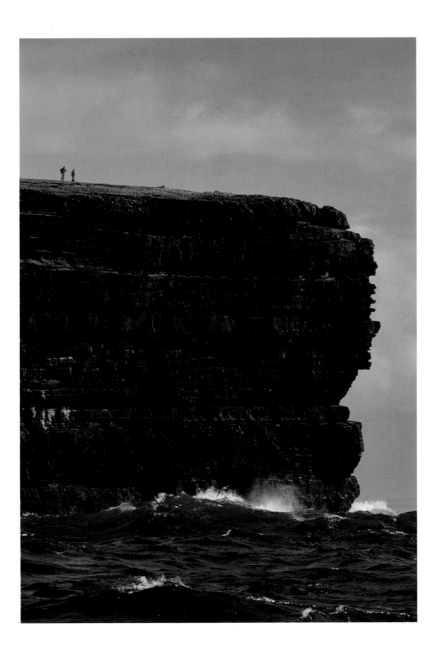

EAT & STAY
€€€ Oar Restaurant and Rooms

In the centre of the village of Doolin, Oar is a restaurant with rooms that pushes all the buttons. Kieran describes the cooking as "rustic fine dining" which sounds like an oxymoron, until you eat rump of lamb with feta and pomegranate, or rib-eye with agrodolce onions, and you realise that is exactly what the kitchen has achieved: gutsy, vivid flavours in serene, polished, cheffy creations. The rooms upstairs are comfortable and have all you need, and Oar is a new west coast star. *Toomullin, Roadford, Co Clare, oardoolin.ie +353 65 704 7990. Open dinner.*

EAT
€€ Stonecutters Kitchen

Karen and Myles have all the details of deliciousness down to a fine art in the friendly Stonecutters Kitchen. Put their smart, super-tasty cooking and warm service in a century-old stone cottage, and you have a real winner, another of those quixotic and charming ventures that form the backbone of the hospitality culture of County Clare. Lots of swings and slides outside so the kids can tire themselves out. *Doolin, Co Clare, stonecutterskitchen.com +353 65 707 5962. Open daytime.*

STAY
€€€ Hylands Burren Hotel

The Quinn family run both this fine traditional hotel and bar, and their L'Arco restaurant, just down the street. The bar in the hotel has always been famous as a cosy spot to eat – seafood and shellfish are a highlight – and it's a classic spot in which to enjoy great music sessions. *Main St, Ballyvaughan, Co Clare, hylandsburren.com +353 65 707 7037.*

Local Speciality – Burren Free Range Pork Farm

Like all philosophers of living, Eva and Stephen rear happy pigs. Bring the kids to stay in their converted horse box – real country glamping! – and you and the kids will see the good life, up close. *Kilfenora, Co Clare, burrenfreerangepork.com*

EAT **An Fear Gorta**

€ Jane O'Donoghue's lovely tea rooms and garden are a Ballyvaughan classic, and have been since opening in 1981. Aside from the famous table, which is always laden with cakes and desserts, there are many savoury choices, and proper sandwiches. A good hike along the coast road followed by afternoon tea is some sort of Burren bliss. *Pier Rd, Ballyvaughan, Co Clare, tearoomsballyvaughan.com +353 65 707 7157. Open daytime. Seasonal.*

EAT **O'Loclainn's Bar**

€ O'Loclainn's is one of the most beautiful bars in Ireland. It is intimate, it is somehow zen-like, it's wildishly handsome, and it offers a jaw-dropping selection of whiskeys. In fact, O'Loclainn's is probably the Irish pub we would most like to be locked into, to answer your question. Time stands still from the second you walk through the narrow green doors, and enter another world. *Ballyvaughan, Co Clare +353 65 707 7006.*

EAT & STAY **Gregans Castle**

€€€€ A little way up winding Corkscrew Hill, just outside Ballyvaughan, Gregans Castle is for many food lovers the defining example of the Irish country house experience. Simon Haden and Frederieke McMurray orchestrate a tone poem of superlative design, throughout the public and private rooms, whilst Robert McCauley is in complete command of the kitchen, producing the most elegant, finessed country cooking: yeast roasted veal sweetbreads with cauliflower; East Clare venison with preserved blackberry; halibut with sea purslane and razor clams. The food served in their commodious bar is almost as fine as the restaurant cooking, and whilst Gregans is a not an inexpensive experience, it is worth every cent. The staff, some of whom have been here for decades, are superlative. *Corkscrew Hill Rd, Ballyvaughan, Co Clare, gregans.ie +353 65 707 7005.*

EAT **Burren Cafe**

€ Kasha and John Connolly have created one of the quirkiest destinations in the Burren, a mile or so up the hill from Bellharbour. It's a coffee house, a bean-to-bar chocolate factory, and a series of smart tasting rooms, in an idyllic location. Top class, and the sort of place you only find in County Clare. *Oughtmama, Bellharbour, Co Clare, hazelmountainchocolate.com +353 65 707 8847. Open daytime.*

EAT **Julia's Lobster Truck**

€ Julia Llewellyn runs one of the finest food trucks in the country. Her lobster rolls have no peer, because here is a cook who gets the interplay between ingredients and bread just so, making for sexy, soulful eating. The only problem is, after one lobster roll, you crave another. And it's the same story with her mussels and clams, her superb fries. A pint of porter from Daly's bar, and a Julia's lobster roll, and sure all is right with the world. *Daly's Bar, Bellharbour, Co Clare and other seasonal locations, @juliaslobstertruck +353 87 616 7277. Open dinner. (See photo opposite).*

Local Heroes – Russell Gallery

Stefania Russell runs yet another of those quixotic, idiosyncratic and charismatic food and hospitality businesses that – it seems – you can only find in the Burren in County Clare. It's a beautiful gallery with covetable work in every artistic form. But it's also a fine place to stop and enjoy good food and drinks served in the European style: simply, charmingly, without pretension. *New Quay, Burren, Co Clare, russellgallery.net +353 65 707 8185. Open daytime.*

Just Off The Way

The WAW scoots from North Kerry to South Clare by means of the Tarbert Ferry. If you don't take the ferry, you'll find yourself going through the busy city of Limerick.

Limerick Strand Hotel Lovely food from head chef Tom Flavin, and fantastic city views from the upper storey rooms. (strandhotellimerick.ie)
One Pery Square A beautiful boutique hotel right smack in the old part of the city. Fine spa and wine shop. (oneperysquare.com)
The Mustard Seed South of the city in Ballingarry, and one of the best country houses in Ireland. (mustardseed.ie)
Canteen Funky space with smartly executed casual food. (wearecanteen.com)
La Cucina Centro Cracking Italian food from Bruno and Lorraine. (lacucina.ie)
The Limerick Milk Market Great shopping, great eating, great experience. (milkmarketlimerick.ie)
Mortell's A modest space, with mighty cooking. (mortellcatering.com)
Freddy's Bistro Liz and Caroline are a great duo, offering very fine cooking. (freddysbistro.com)
The Grove Veggie Kitchen Almost 40 years young, and still doing the good veggie thing. (@TheGroveVeggieCafe)
Cornstore Restaurant This is the place if you hanker for a tomahawk steak. (cornstore.ie)
House Smart pub with good food. (houselimerick.ie)

Curragower Pub Hearty and delicious gastropub cooking. (curragower.com)

Just a couple of miles inland in Co Clare is the foodie town of Lisdoonvarna.
Kilshanny House Just south of the town, and one of the most pristine pubs. (kilshannyhouse.ie)
Burren Smokehouse Some of the best smoked fish, and a great visitor experience. (burrensmokehouse.com)
Roadside Tavern and **Burren Brewery** One of the finest traditional pubs in Ireland.
Sheedy's Hotel The most charming family-run hotel you can find. (sheedys. com). (See photos p. 102)
Wild Honey Inn Superlative cooking, in a charming country pub with rooms. (wildhoneyinn.com)

Pretty Ennistymon, just off the way, boasts two great food destinations:
Little Fox One of the best regarded new rooms, with smashing farm-to-fork food from Niamh Fox. (littlefox.ie)
The Cheese Press Sinead ni Ghairbhith's room is a true Clare charmer, with great coffee and lovely food. (@CheesePressEnnistymon)

Burren Perfumery Don't miss the Perfumery, one of the most charismatic Burren destinations. The café is a delight, the perfumes enchanting. (burrenperfumery.com)

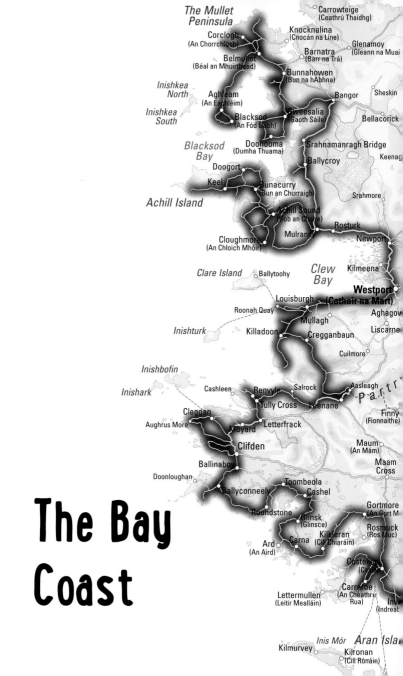

The Bay Coast

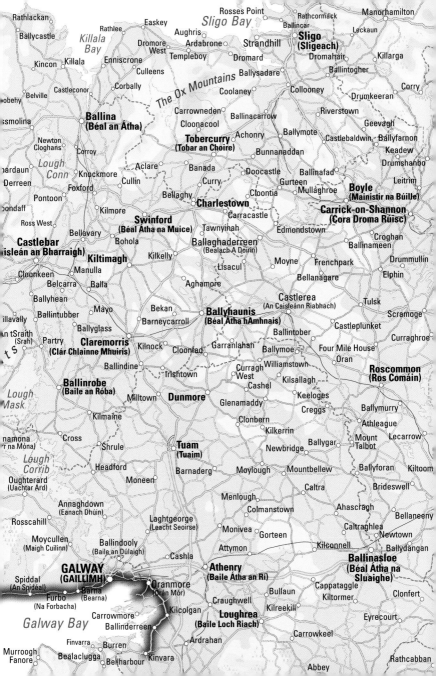

EAT Tide Full Inn
€€ Marianne and Joseph have moved from their original Kinvarra address, and their rock-steady offer of great Italian pizza, excellent drinks and some fine artisan foods is as seductive as ever. The room is colourful and cheerful, and the pizzas are classic. *Glebe Road, Kinvarra, Co Galway, thetidefullinn. com, +353 91 638468. Open evenings from 3pm.*

EAT Moran's Oyster Cottage
€€ Moran's has been doing the good thing with west coast fish and shellfish for centuries, but the formula of cosy rooms with warm fires and finger lickin' cooking never ages a jot. Brown soda bread, half a dozen edulis oysters and a glass of stout: hits the spot. *The Weir, Kilcolgan, Co Galway, moransoystercottage.com, +353 91 796113. Open lunch & dinner.*

EAT & STAY Armorica
€€€ If you love the French concept of the restaurant-with-rooms, you will love Natasha and Nicolas's Armorica. In the restaurant, Nic brings French technique to superlative west coast ingredients – Friendly Farmer chicken, wild hake. It's just the right food and, next morning, make sure to order Nicolas's omelette: you won't find a better rolled omelette anywhere in Ireland. *Main St, Oranmore, Co Galway, armorica.ie +353 91 388343. Open daytime & dinner. (See photo, page 119, top).*

EAT & STAY Basilico
€€€ Paolo Sabatini and Fabio Mulas have their own farm, just north of Galway, supplying ingredients straight into Basilico, and the quality of that fresh produce lifts to the stars the elegant cooking that distinguishes this restaurant. This is some of the truest, most delighting Italian food you can find on the WAW. Comfortable rooms in the Coach House Hotel mean you can enjoy the good Italian wines. *Main St, Oranmore, Co Galway, basilicorestaurant.ie +353 91 483693. Open lunch & dinner. (See photo opposite).*

EAT **Brazco Coffee Academy**
€ Sinead Tormay's little room beside the Texaco station is perpetually jammed with happy coffee heads, all of them enjoying the expert brews and superb service that are the hallmarks of this essential Oranmore destination. *Main St, Oranmore, Co Galway, brazcocoffeeacademy.com +353 91 388342. Open daytime.*

EAT **Delight Health Café**
€ Delight is run by Kevin Nugent, who also runs the popular Ground & Co cafés on the west side of the city. Good coffee from the fine Bell Lane Roastery and excellent juices set the scene for tasty food which has a strong focus on holistic healthfulness. *Renmore Av, Renmore, Co Galway, delight.ie +353 91 761466. Open daytime.*

STAY **The G Hotel**
€€€€ The G may be the most luxe hotel in Ireland. With interiors created by milliner Philip Treacy, it's garish, glam and girlish. Don't worry that the location is less than ideal: The G is actually an ocean liner, and when you step in the doors, you leave the everyday world far behind. Jason O'Neill is the chef in the hotel's main restaurant, gigi's, and his food is gracious and well-judged. *Wellpark, Galway, theghotel.ie, +353 91 865200.*

EAT & STAY **The Huntsman Inn**
€€€ The secret to the success of The Huntsman Inn is simple: owner Stephen Francis and his crew are always looking forward, are always striving to be better, to be their best. Every detail of The Huntsman Inn is thought through, from the excellent cooking in the bar and restaurant, to the luxurious rooms upstairs for guests, from the expert and considered drinks offer to the sociable, expert Galway service. Comfortable, classy and confident, the Huntsman Inn is a West Coast classic. *164 College Rd, Galway, huntsmaninn.com +353 91 562849.*

Just Off The Way

Coole Park Tea Rooms A stroll – or even a 5km run! – through the beauteous grounds of Lady Gregory's old gaff, followed by brunch in Sarah and Cillian's lovely tea rooms is some sort of magic: cep arancini with Jerusalem artichoke purée and Parmesan for me, please. (coolepark.ie)

The Gallery Cafe An art-filled room on the square in Gort is home to Sarah Harty's true hospitality and fine cooking. Nice music gigs at the weekends, excellent exhibitions by local artists, and tasty food: Doonbeg clams and mussels with linguini; turkey and courgette burger. (thegallerycafegort.com)

Raftery's Lounge Meticulous cooking and housekeeping from Rachel Raftery make this Craughwell bar, run by the Raftery family for four generations, a true Galway classic. Worth the trip for the chowder and brown bread. (@rafterysbar.craughwell)

The Old Barracks Fiona runs both the bakery and a bistro here in Athenry, and sources directly from the farm. There are fine, comfortable rooms to stay the night in their Lodge, with breakfast next morning in the restaurant. (oldbarracks.ie)

Lignum Danny Africano's dynamic cooking, in a serenely gorgeous room in Bullaun, just north of Loughrea, hit the west with the force of a tornado. Mind-expanding cooking from the chef and his top-notch crew: the roast duck with celeriac and cavolo nero is as fine a thing as you can eat, and Lignum is a star destination. (lignum.ie)

EAT **America Village Apothecary**
€ When it comes to drinking, Claire Davey is out-of-the-box and, in her AVA Tasting Rooms on Dominick St, in the West End, she has fashioned a bar unlike any other drinking destination in Ireland, with drinks unlike anyone else's drinks. AVA is an old chemist's shop, and looks like an alchemist's lair. It doesn't feel like an Irish bar, in any shape or form: it is sui generis. There is nowhere else even remotely like it, so pull up a stool. *31 Dominick St Lwr, Galway, americavillage.com +353 87 955 3560. Open afternoons and evenings. (See photo opposite).*

EAT **Aniar**
€€€ Pause for a second, and take a close look at the foundations of JP McMahon's food in Aniar, and you will find that what you are getting excited about is, ahem, a blue cheese scone. Or a piece of soda bread. Or a chicken heart. Mr McMahon's secret is that his starry cooking pays as much respect to simple things – bread; scones; kelp; butter; leeks; pickled onions – and it is because he does this, and because he has deep foundational skills, that Aniar cooking is so soulful, site-specific, and thrilling. To get the best from Aniar, choose the tasting menus with the wine pairings, which will bring you up close to unique combinations of taste and texture. *53 Lower Dominick St, Galway, aniarrestaurant.ie +353 91 535947. Open dinner.*

EAT **Ard Bia**
€€€ Owner Aoibheann McNamara talks of having roots in one place, whilst having an imagination that roams the globe, and Ard Bia does just that: you come to Spanish Arch to eat Turkish baked beans, and vegan quinoa cakes, Burren smoked haddock with squid ink sourdough. The food is both firmly rooted in the West of Ireland, and wildly imaginative, supremely fun. Great, funky staff pull the wildness together. *Spanish Arch, Long Walk, Galway, ardbia. com +353 91 561114. Open breakfast, lunch & dinner.*

EAT **Asian Tea House**

€ Start with a good cocktail in the Buddha Bar, and let the booze and the moody Oriental furnishings get you in the mood for some fine Asian food. You can eat in either the bar or the stylish restaurant, with good popular dishes that roam all over Asia – Massaman chicken curry; Indonesian rendang; wok-fried duck. *5 Mary St, Galway, asianteahouse.ie +353 91 563749. Open dinner.*

EAT **Brasserie on the Corner**

€€€ If you want to experience the vivacious energy that defines the capital of the West, then Brasserie on the Corner is the perfect portal. You step in the doors and suddenly you are in a place where everything feels more vivid, more real, more welcoming. And the cooking in the Brasserie drives home this feeling of enchantment – the signature Brasserie Boards with their ample deliciousness; salt cod croquettes; Killary Harbour mussels; scallops with herb risotto and Parmesan crisp; 6-hour lamb shoulder with salsa verde; classic vanilla crème brûlée. It's perpetually busy, so get a drink at the bar as you wait for that table. *25 Eglinton St, Galway, brasseriegalway.com +353 91 530333. Open lunch & dinner.*

EAT **The BurgerStory**

€€ Enda and Tara source their raw ingredients from the very best west coast artisans – chicken wings made with Friendly Farmer birds; beef and bacon from the finest local suppliers; great drinks – so the BurgerStory story is something we might describe as Slow Food Fast Food – food that eats like a sumptuous banquet, whether it's a Double Damnation burger, or the Triple Decker, or the bacon cheese fries. Hats off also to excellent staff, and to the great American rock'n'roll soundtrack that sets the raucous mood of this rockin' destination. *1 Quay Lane, Galway, burgerstory.ie. +353 85 735 208. Open lunch & dinner.*

EAT Cava Bodega
€€€ JP McMahon's Cava Bodega is probably the most popular restaurant in Galway. McMahon and his team love the queer gear of Iberian food – pig's head fritters; chicken hearts with chorizo – and the surprise is that these dishes are just as popular as patatas bravas, or salt cod with romesco, or lomo ham. The atmosphere in the basement dining room is always up to 90 as everyone tears into tasty Spanish tapas and the excellent wines and sherries from Spain, and the dizzying mood is driven on by punky and vivacious service. Major fun. *1 Middle St, Galway, cavarestaurant.ie +353 91 539884. Open dinner.*

EAT Coffeewerk & Press
€ Daniel Ulrichs brings us beautiful coffee and sweet snacks downstairs, with beans from Berlin's The Barn and Copenhagen's Coffee Collective, whilst upstairs there are design objects whose beauty will melt your heart. Mr Ulrichs and his crew are coffee obsessives, agonising over every detail of the process, and the result is spellbinding coffee and hot chocolate. Mr Ulrichs also seeks out design and art objects 'that appeal to the physical and aesthetic'; his design objects hit those desired targets with ease. *Quay St, Galway, coffeewerkandpress.com +353 91 448667. Open daytime.*

EAT & STAY Corrib House Tea Rooms & Guest Accommodation
€€€ This 200-year-old riverside house is a pure delight. Caoimhe has all the confidence and flair that you expect from a Galway girl, so her energised and witty style powers the tea rooms, and makes for a most welcoming house for guests who want to stay in the heart of the city. Outside, the River Corrib flows torrentially, but that's okay: you are cosy inside this Galway jewel. Bounteous breakfasts, tasty daytime treats. *3 Waterside, Galway, corribhouse.com +353 91 446753.*

EAT **Dela**

€€€ Dela is different. As restaurateurs, Joe and Margaret Bohan are out-of-the-box, and the style and service of their Dominick St room is an antidote to conventional restaurant styles. They offer thoughtful food, and it's not fanciful to describe it as mindful, for a lot of consideration goes into deciding to offer pickled salad with silver hake, or putting radish into a mousse with smoked salmon. In Galway's extraordinary mosaic of great cooking, Dela has secured its own solo spot. *51 Lower Dominick St, Galway, dela.ie +353 91 449252. Open daytime & dinner.*

EAT **Dough Bros**

€€ In just a few years, brothers Eugene and Ronan have gone from food cart, to pop-ups, to one of the most rockin' bricks-and-mortar destinations on the west coast. One bite of their pizzas will explain the success: the brothers have worked it out, and know how to make the most perfect Neapolitan pie. But their success lies also in the fact that they show reverence for the great Italian tradition, whilst at the same time not being reverential, which allows them to improvise pizzas in a fashion that Italian chefs would never presume to attempt. There is no other room like it. They have another outfit – Dough O'Connell's – on Eyre Square. *1 Cathedral Building, Middle St, Galway, thedoughbros.ie +353 91 395238. Open lunch & dinner. (See photo page 121).*

EAT **56 Central**

€€ Gill Carroll made her name with the thunderously successful 37 West, out at Newcastle, before bringing the same formula of accessible, affordable and enjoyable food into the centre of Shop Street. Gill just knows what people like to eat – perfect pancakes for breakfast; lemon tart with cream because you deserve it. Friendly, charming, pure Galway. *5 Shop St, Galway, 56central.com +353 91 569511. Open daytime, and evenings at weekends.*

STAY The Galmont Hotel & Spa

€€€ Great staff power the super-busy Galmont, one of the epicentres of Galway's civic life, and a place where it always feels like it's Friday evening, 6.30pm. If you have the money, do book one of the suites on the 5th floor: these rooms are extra-special, with terrific views from private balconies. *Lough Atalia Rd, Galway, thegalmont.com +353 91 538300.*

EAT Goya's

€ Emer Murray is one of the best bakers in the city, and there is nothing like a slice of her perfect cake, and a good cup of tea. *2/3 Kirwan's Lane, Galway, goyas.ie +353 91 567010. Open daytime.*

EAT The Gourmet Offensive

€ Whilst The Gourmet Offensive is best known for their busy stall in the Galway Market, they do the good vegetarian and vegan thing in this cosy, colourful space, so go for The Worx, or get classic falafels with hummus, salads and pickles in a wholemeal pitta. Their chips are regarded by many as the best in the city. *11 Mary St, Galway, @GalwayFalafel +353 86 189 0655. Open daytime and at the Galway market at weekends.*

EAT Handsome Burger

€€ In Handsome Burger, the staff treat you royally. They don't pay for your drinks, but they do pretty much everything else they can to make your visit special. Happily, the burgers are, of course, just whizzo. Rory McCormack and Cathal O'Connor planned everything carefully as they evolved from market stalls and pop-ups to their hip bricks-and-mortar base. The signature Handsome Burger is bang on, and the house fries with rosemary and sea salt are pretty perfect. Great beers from White Hag and Galway Bay pair up just perfectly. *Lady Gregory House, 49 Dominick St Lwr, Galway, handsomeburger.com +353 91 533992. Open lunch & dinner.*

STAY **Heron's Rest**

€€€ Sorcha Molloy's lovely Heron's Rest is as close to the River Corrib as you can get whilst still keeping your feet dry. It's the perfect city break destination, both B&B and town house, and Ms Molloy's breakfasts are the stuff of legend. And is there actually a real, live heron?, you ask. Of course there is: just ask the boss for the story. *16a The Longwalk, Galway, theheronsrest.com +353 91 539574.*

EAT **Hooked**

€€ The fish comes straight from their sister operation, Ali's Fish Market, which is just around the corner, so the piscine quality is top notch at this fish and chips and seafood restaurant. The space is a nice, modest mix of chipper, café and restaurant and it has a great ambience. *65 Henry St, Galway, hookedonhenryst.com +353 91 581752. Open dinner & weekend lunch.*

STAY **The House Hotel**

€€€ A charming, friendly hotel, with a peachy location close to the docks in the Latin Quarter. Rooms are intimate, and stylish, the staff are top class. *Lwr Merchant's Rd, Spanish Parade, Latin Quarter, Galway, thehousehotel.ie +353 91 538900.*

EAT **Kai**

€€€ People love Kai: the room; the service from David Murphy and the team, the panache and funky attitude of Jess Murphy's cooking. The menu has never strayed from its 5x5x5 tautness, and it delivers every time: Jean's pressed ox tongue with gherkins; Roscommon lamb with beetroot picada; Rossaveal hake with burnt butter cauliflower; Hokkaido pumpkin pie. Kai food delivers lashing of flavour and lush textures, which is why it's always packed, and why there is a lengthy queue down the street for brunch at weekends. *Sea Rd, Galway, kaicaferestaurant.com +353 91 526003. Open daytime & dinner.*

EAT **Kappa-ya**

€€ Junichi Yoshiyagawa's tiny room is home to some lovely Japanese cooking – eel sushi roll; breaded bluefin tuna; katsudon; kaisen-don with wild trout; chilled ramen. The style is simple, charming and truly echt. *4 Middle St Mews, Galway, @kappaya.galway +353 91 865930. Open lunch & dinner.*

EAT **The Kasbah Wine Bar**

€€ The Kasbah kitchen provides food for the legendary Tigh Neachtain pub, downstairs from the restaurant, and also for their elegant dining room, upstairs from the pub. The cooking is eclectic and intriguing – adobo pork tacos with slaw; lobster with home fries – and pairs up really well with the superb wine list, which is packed with gems and offers great value for money. *Tigh Neachtain, 2 Quay Street, Galway, kasbahwinebar.ie +353 85 734 0164. Open dinner.*

EAT **The King's Head**

€€€ Paul and Mary Grealish run the pub of your dreams, and offer the food of your dreams, offering a palette of dishes from the Wild Atlantic Way: west coast seafood chowder with brown bread; Aran Island goat's cheese salad; hake with foraged sorrel butter; rhubarb crumble. The cooking and the service offer that soulful Galway hospitality that is simply unique, and The King's Head is an Irish classic. *Olde Malt Mall, High St, Galway, thekingshead.ie +353 91 566630. Open lunch & dinner.*

EAT **John Keogh's Gastropub**

€€ Chef Joe Flaherty's cooking in Matt Hall's pub has won every imaginable award, and for a simple reason: this is real, west coast, modern Irish cooking: slow-roast lamb shoulder with champ and green peas; Gilligan's char-grilled sirloin; peanut butter parfait. Rockin' cooking in a rockin' West End pub. *22 Upr Dominick St, Galway, johnkeoghs.ie +353 91 449431. Open dinner & weekend lunch.*

EAT The Kitchen @ Galway City Museum

€€ Michelle Kavanagh and her team make it look as if it's easy to do what they do in The Kitchen, at the City Museum. But it's not easy to be as precise about flavours and textures as the team here are, and their secret ingredient is simply that Ms Kavanagh is an avid student of the culinary arts, always seeking new ideas, new inspirations. Superb. *Spanish Arch, Galway, thekitchengalway.ie +353 91 534883. Open daytime.*

EAT The Lighthouse Café

€ People love Alison Haslam's friendly café and the imaginative vegetarian cooking – courgette, black-bean and onion cassoulet; the Jeremiche sourdough sambo with roasted beets and tarator; walnut burger with vegan feta. Charming. *8 Abbeygate St Upr, Galway, @TheLightHouse +353 91 568706. Open daytime.*

EAT Little Lane Coffee Company

€ Jen and Graham use beans from the brilliant Calendar Coffee – roasted out in Barna – so that soulful cup of Vitaliano Merino is right here waiting for you. Look out for their flower-bedecked facade, then head inside for top-notch Galway toasties and sausage rolls. *10 Abbeygate St Upr, Galway, @littlelanecoffeecompany. Open daytime.*

EAT Loam

€€€ Enda McEvoy's cookery isn't like anything else you can eat in Ireland. Served in a large, hangar-like room unlike any other Irish dining room, and using only West of Ireland ingredients, McEvoy maxes out his capacious techniques in dishes such as potato and egg, or scallops with celeriac. The dishes sound simple, but the complexities are jaw-dropping and, to be honest, at times it seems that there is nothing this guy can't cook, and Loam dishes achieve an ethereality no other cook can match. *Fairgreen, Galway, loamgalway.com +353 91 569727. Open dinner.*

EAT Matt's Sandwiches

€ The big blackboard announces Matt's menu of funky sarnies – The Corrib; The Uni; The Humpty Dumpty – and with excellent coffee from first division roasters, the only problem is trying to decide which of the dozen or more sandwich delights you actually want to eat today. *40 Lower Newcastle, Galway, mattssandwiches.ie +353 91 527880. Open daytime, and weekend mornings.*

EAT McDonagh's Seafood House

€€ McDonagh's is both a hugely popular fish restaurant, and an award-winning chipper. Indeed, their fish and chips are regarded by locals as not just the best in the city, but as being amongst the best in the country. The atmospheric restaurant is always packed, so expect to wait for a table. *22 Quay St, Galway, mcdonaghs.net +353 91 565001. Open lunch & dinner.*

EAT Marmalade

€ Michelle Kavanagh's artisan bakery is a little beauty. Whilst everyone compares it to destinations in Copenhagen, to us it's pure Galway, with superb sourdough breads underpinning excellent savoury and sweet treats, not least their soon-to-be-legendary sausage rolls, underpinned by charming staff. Excellent breakfasts, great sandwiches. *Unit 3 Middle St Court, Galway, marmaladegalway.com +353 91 0283 4726. Open daytime. (See photo opposite).*

EAT Martine's of Quay Street

€€€ Martine's is one of those illustrious Galway institutions that succeeds by doing what it does the way it has always done it: cooking excellent food that makes people happy, ensuring they come back time and again, and doing everything they do with a smile. Martine and her team could coast by on Galway's tourist trade, but they don't: every day they make it new. Superb wine list. *21 Quay St, Galway, winebar.ie +353 91 565662. Open lunch & dinner.*

EAT McCambridge's

€ For 90 years, McCambridge's has been the pivot of Galway's food culture, a shop whose doctrine of excellence and service has only ever improved with the passing of the years. The family's philosophy is that you "have to reinvest and reimagine the business every few years", and they do just that. Their café, Upstairs @ McCambridge's is one of the city's most charming rooms and they are part of the Galway Whiskey Trail – there are some serious bottles for sale here, at serious prices. The shop and café are a vital catalyst for the city, and McCambridge's is one of the glories of Galway. *38/39 Shop St, Galway, mccambridges.com +353 91 562259. Open daytime.*

EAT Merrow

€ Merrow is a gorgeous, mirror-lined room on the ground floor of the Palas art house cinema, with a bar upstairs which has magical Patrick Scott painted windows. Superlative sourcing from the best in the West means the food has real verve and imagination – crispy haddock with capers and potato salad; aubergine and chorizo stew with toasted focaccia; steak and cheese burger with slaw – and the drinks are pure class. Just delightful. *Pálás Cinema, 15 Lower Merchant's Rd, Galway, palas.ie +353 91 394800. Open daytime & dinner.*

EAT Tigh Neachtain

€ You pronounce it 'Nokton' and having a drink in what may be the most famous pub in the city is a rite of passage: if you haven't had a glass of Redbreast or a pint of Galway Hooker in the bar, well, then you haven't actually been to Galway. A sepia-tinged warren of cosy snugs, amiable crowds, and some nice food, cooked by the team upstairs in The Kasbah, Neachtain's is as classic as an Irish pub can be. Serene staff somehow cope with the endless crowds. *17 Cross St, Galway, tighneachtain.com +353 91 568820.*

EAT Oscar's
€€€ Michael O'Meara and Sinead Hughes were the first restaurateurs to colonise Galway's West End in the name of good cooking and, two decades later, O'Meara's seafood cookery, and Ms Hughes' superb service, keep Oscar's at the top of Galway eating. Mr O'Meara is a curious, intelligent cook, and his knowledge of the riches of west coast seafood is second-to-none: his book, *Seafood Gastronomy*, is regarded as a modern classic. *22 Upper Dominick St, Galway, oscarsseafoodbistro.com +353 91 582180. Open dinner.*

EAT Le Petit Delice
€ Galway's culinary reputation rests on stalwart superstars like Alexandra Saivre's Le Petit Delice. You come to this pretty room for sweet and savoury treats, for tea and coffee, for the chance to enjoy a moment of respite from the fever that is Galway. Even if you aren't taking a table in the café, the bread and sweet counter, with its colourful bricolage of baking, is a treat, and the Petit Delice baguette is regarded as the best in town. *7 Mainguard St, Galway, @LePetitDelice +353 91 500751. Open daytime, till 7pm.*

EAT Sheridan's Cheesemongers & Winebar
€€ Sheridan's is unique. On the ground floor you will find the best cheese shop in Ireland. Upstairs you will find the best wine bar in Ireland, with amazing wines, and delicious cheese and charcuterie plates. But it's not just the wines and cheeses that make Sheridan's special: it's the atmosphere, the ambience, the staff, the buzz that happens when you put a bunch of the most interesting people in a city into one room in Ireland's most interesting city. It's not a wine bar: it's a salon, and there is nowhere else like it. *14-16 Churchyard St, Galway, sheridanscheesemongers.com +353 91 564829 (shop) +353 91 564832 (wine bar). Open evenings for wine & cheese.*

STAY **The Stop**

€€ However you assess cult status, Galway's The Stop B&B tops it, and then some. Russ and Emer's modestly magnificent house betrays their gallerist backgrounds, with the precise and perfect placing of every object, and the result is feng shui heaven, right down to the placement of the sleeves of the classic vinyl records that play each morning. Bathe all this design glory in the bright light of a Galway morning, and you have a superlative destination. *38 Father Griffin Rd, Galway, thestopbandb.com +353 91 586736. (See photo page 137).*

EAT **Wa Sushi**

€€ "My nigiri tells a story," says Yoshimi Hayakawa, chef-proprietor of Wa Sushi. In fact, Ms Hayakawa's sushi tells many stories, not least how her restaurant has crafted something unique in the creation of Galway-Mae sushi, which means Wa Sushi only uses fish and shellfish from Galway Bay. The result of this journey is a cuisine of emotional power, and aesthetic purity. The finesse of a sushi creation like squid noodle, or John Dory kobujime, is artfulness incarnate. *13 New Dock St, Galway, wacafe.net +353 91 895850. Open lunch & dinner at weekends. (See photo opposite).*

EAT **Tartare**

€€€ Whilst Aniar is JP McMahon's starry culinary citadel in Galway, and Cava his funky Iberian home-from-home, Tartare, may be – just may be – his masterpiece. It's a radical little room, with a hip-hop soundtrack, and it upends expectations in every way. The cooking is 4-star in every way, offering pristine renditions of staple dishes – oysters with sea lettuce; beef tartare with smoked egg; potatoes with sea herb butter; raw milk mousse with malted purée – and all the time unveiling the most profound expression of flavour. Sublime. *56 Dominick St Lwr, Galway, tartaregalway.ie +353 91 567803. Open daytime & dinner.*

EAT **37 West**
€€ Gill Carroll's café has a mission – to serve delicious, affordable, healthy food – and every day they not only achieve that ambition, they exceed it. Whether you are here for the smashed avo with scrambled eggs or the Muscle Builder salad, you will enjoy delicious, affordable, healthy cooking. *37 Lwr Newcastle Rd, Galway, 37westcafe.com +353 91 524122. Open daytime.*

EAT **'U Liotru Sicilian Street Food**
€€ Good arancini, stuffed with ingredients such as spinach and ricotta, Italian sausage, mushrooms and ragu, and fine cannoli for dessert bookend the offer in this simple room. But don't overlook some very fine lasagne dishes – with spinach and mushroom; with bolognaise – and the signature aubergine rolls stuffed with spaghetti. Good coffee, paper plates for the snacks, and a spare guitar in the corner if you are in the mood for serenading. *Abbeygate St Lwr, Galway, @uliotrusicilianfood +353 91 562904. Open lunch & dinner.*

EAT **The Universal**
€€ Matt Davis is cooking some ace food in the Universal, one of those welcoming bars that is packed with regulars. The fried chicken with tonkatsu is wickedly good, while the Castlemine lamb chops with aubergine and hazelnut yogurt is lip lickin' good. Great drinks, cool staff, hot destination. *9 William St West, Galway, @theuniversalbar +353 91 728271. Open dinner from 4pm.*

EAT **Urban Grind**
€ A perfect cup of 3fe San Gaetano and a Wagon Wheel is just the sort of thing that brings people back to Padraig and Lisa's hip Urban Grind. Or you might decide on a breakfast burrito and a can of cold brew. The latte art is simply superlative. You'll be back. *8 William St West, Galway, @UrbanGrindWest +353 91 375000. Open daytime.*

EAT Il Vicolo
€€€ Gerry McMahon and his Il Vicolo team have a beautiful space in the Bridge Mills building, a trio of stone-clad rooms where the River Corrib – literally – rushes underneath you. Their signature style of Italian small plates, cicchetti, and larger plates is rock-steady and invigorating. *O'Brien's Bridge, Galway, ilvicolo.ie +353 91 530515.*

EAT Wholly Cow
€ Val Lynam is a pretty obsessive dude: he worries about the provenance of his beef, his buns, his pickles. He fusses over his kimchi and his barbecue sauce. The result of all this brow-furrowing – the Wholly Cow burger – is a burger so fine that it stops you in your tracks, hitting all the flavour points with an assassin's accuracy. *An Grianan Geal, Newcastle Rd, Galway, @whollycowburgers +353 91 586888. Open lunch & dinner. (See photo p 141 & opposite).*

EAT Black Cat
€€ Joanna and Leon use ingredients from the best west coast artisans to create their tapas menus – lamb sliders with Castlemine Farm lamb; Clew Bay oysters with Guinness granita; Connemara mussels with chorizo; Aran Islands goat's cheese with beetroot purée. There are also platters, salads, sandwiches, and signature dishes in the evenings such as fisherman's stew. Good jazz tunes set the stage. *179 Upper Salthill, Galway, blackcat.ie +353 91 501007. Open lunch & dinner.*

EAT La Collina
€€ You have got to love an Italian restaurant that makes green pasta for St Patrick's Day. But whatever day of the year it is, La Collina's fresh pasta will always be aptly delicious. The pizzas are no slouch either; here is a team, in both the kitchen and at front-of-house, who really do put their Italian heart into it. *169 Upper Salthill, Galway, lacollinagalway.com +353 91 450716. Open dinner, from 4pm & Sun lunch.*

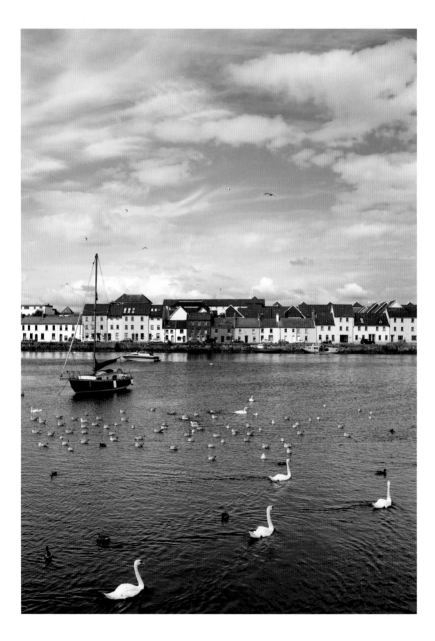

EAT Gourmet Tart Co

€ The cooking in the GTC is every bit as stylish as this gorgeous room. Start the day with a bowl of power porridge with maple syrup, or Colleran's bacon with a free-range egg, and you'll be back at lunchtime to try the pasta alla Norma, or the Thai duck salad with sweet potato fries. Great for brunch on Sunday – blueberry buttermilk pancakes; eggs Royale. A real Salthill classic. *171 Salthill Upr, Galway, gourmet-tartco.com +353 91 861667. Open daytime.*

EAT Ground & Co

€ Kevin Nugent's hugely popular coffee bar, just at the Aquarium entrance, has become a Salthill institution, and there is also a second branch at Knocknacarra. *Salthill, Galway, groundandco.ie +353 91 527846. Open daytime.*

STAY The Nest

€€ The Nest is a hostel, but it's known by locals as a "Poshtel", which gives you a clue as to the stylish decor and witty and artistic style that owner Keith Kissane has gifted to this fine old house. The aesthetic value of The Nest is exceptionally chic, modern, classic, simplistic and clean. The lobby is the epicentre of the house, where guests enjoy a very sophisticated breakfast, with local fresh breads, scones and little pots of muesli to be enjoyed with yogurt. *107 Upper Salthill, Galway, thenestaccommodation.com +353 91 450944.*

EAT Oslo

€ Oslo is a bustling big bar and brewery, at the seaside end of Salthill. Of most interest to visitors is their range of craft beer from their own Galway Bay Brewery. These are superb craft beers and they match up with the modern tasty food served in the bar. Most of the Irish craft beers are also sold, as well as a great range of international brews. *Salthill, Galway, galwaybaybrewery.com +353 91 448390.*

EAT & STAY
€€€
The Twelve

Chef Martin O'Donnell and manager Fergus O'Halloran make it look easy to run a cutting-edge restaurant and a funky, boutique hotel. But both West Restaurant and The Twelve Hotel are driven by an inexorable need on the part of both men to keep improving, and every return visit shows that Mr O'Donnell's cooking just gets better and better, offering some of the most distinctive and original food on the WAW. *Freeport, Barna, Co Galway, thetwelvehotel.ie +353 91 597000.*

EAT
€€
Hooked Barna

Sister restaurant to the popular Galway city centre outpost, so expect the same excellent chowder, perfect fish and chips, and a fine fish burger, with all the seafood coming to Barna from Ali's Fish Market. *Unit 20 Barna Village Centre, Barna, Co Galway, hookedonhenryst.com +353 91 596623. Open lunch & dinner.*

STAY
€€€
Connemara Coast Hotel

The Connemara Coast has that ocean liner effect – when you drive into the car park you leave the rest of the world behind – even though Galway city is only several miles eastwards, and the pretty village of Spiddal is just down the road. Great facilities for the kids means the whole family gets utterly spoiled. *Furbo, Co Galway, connemaracoasthotel.ie +353 91 592108.*

EAT
€
Builin Blasta

Heather Flaherty is a huge talent, who works in a little room, in the craft village just on the edge of Spiddal. She is a rare chef in that she is a complete all-rounder – she bakes as well as she roasts; she sautées as well as she makes puddings. The result is sheer culinary joy, from the morning's coffee and scone to a lunch like her vegan spag bol. No traveller on the WAW should miss. *Spiddal, Co Galway, builinblasta.com +353 91 558 559. Open daytime.*

Aran Islands

Inis Meain

Eating in the Inis Meain restaurant is a stunning experience – the room, the setting, the sunset, Ruiari's cooking, Marie-Therese's service – and it will still be haunting your head weeks after you have returned to the mainland. Mr de Blacam's food appears elemental – scallop ceviche with toasted almonds; lobster bisque; carrots with chives; turbot with spuds – yet this culinary simplicity has a power that goes beyond the pure, gently coddled flavours that you find on every plate. Unique. *Inis Meain, Aran Islands, Co Galway, inismeain.com +353 86 8266026.*

Cáis Gabhair Árann Goat's Cheese

Gabriel Faherty has made a great success of his goat's cheese, made with milk from his handsome Saanen and Nubian goats. His latest cheese is a Goat's Parmesan-style hard cheese. In addition to his cheese, Gabriel also conducts tours of Inis Mór island for groups, which includes a chance to visit the cheese rooms, and this is the tour to book. Oughill, *Inis Mór, Aran Islands, Co Galway, arangoatcheese.com +353 87 2226776 or 87 8635327.*

Joe Watty's Bar

A lively pub that is an Aran institution. Decent food, nice music sessions, and a pleasant walk up the hill out of Kilronan will build up that thirst. *Kilronan,* *Inis Mór, Aran Islands, Co Galway, joewattys.ie +353 86 0494509. Open lunch & dinner.*

Kilmurvey House

Treasa and Bertie run the best B&B on the island, and make the best breakfasts. They are consummate, kindly hosts and, if you stay here for a few days, Aran will creep quietly into your soul. *Kilmurvey, Inis Mór, Aran Islands, Co Galway @kilmurveyhouseguesthouse +353 99 61218.*

Tigh Ned

Tigh Ned pub is owned by a fishing family, and the daily special of lobster or crab is the option to go for, for sure. Great room to hear Irish music in the evenings. *Inis Oírr, Aran Islands, Co Galway, tighned.com +353 99 75004. Open lunch. Seasonal.*

Teach an Tea

Alissa and Micheál Donoghue's family home is the location for their smashing café and tea rooms. Come and eat fresh mackerel with some of Micheál's Orla potatoes and leaves from the garden, or the signature hen's egg salad on brown bread, followed by a slice of rhubarb and almond tart, and the world will seem a perfect place. Alissa has a real cook's touch. *Inis Oírr, Aran Islands, Co Galway, cafearan.ie +353 99 75092. Open daytime.*

EAT Coynes Bar & Bistro

€€ Michael Coyne's family pub and bistro does the simple things well: a classic chowder with perfect, sweet brown bread; mussels in white wine sauce; pan-fried sea trout. There are music sessions at the weekends, along with dancing. An inspirational destination. *Kilkieran, Connemara, Co Galway @ CoynesBarWildAtlanticWay +353 95 33409. Open lunch & dinner.*

EAT & STAY Bogbean

€€ Bogbean is a lively café and a series of five B&B rooms upstairs, in the centre of Roundstone, run by Orla Conneely and Shane McElligott. Orla and Shane are uber-serious sailors and kayak instructors, and can show you how to paddle and stand up on a SUP, courtesy of their company, Roundstone Outdoors. Upstairs, the rooms are comfy. In the café, the welcome is true, the cooking is smashing. *Roundstone, Co Galway, bogbeanconnemara.com +353 95 35825. Open daytime.*

STAY Roundstone House Hotel

€ The Roundstone is a folky, family-owned and run hotel, and we like its modesty and the welcoming hospitality of the Vaughan family. The cooking in Vaughan's bar, and in their restaurant, is a favourite with locals, who come for fresh seafood. *Roundstone, Co Galway, roundstonehousehotel.com +353 95 35864.*

EAT O'Dowd's Seafood Bar & Restaurant

€ Four generations of the O'Dowd family have run this Connemara institution in picturesque Roundstone, acquiring an international audience along the way. They won their status by cooking good, tasty food both in the classic bar and in the restaurant. They stay open all year, so when the winter is in full bloom, getting a seat by the fire is just the thing. *Roundstone, Co Galway, odowdsseafoodbar.com +353 95 35809. Open lunch & dinner.*

STAY **Mallmore Country House**

€€€ The Hardmore family's house is one of those oh-so-perfectly proportioned Georgian houses that seduces the eye from the first glimpse of its elegant finesse. The house is surrounded by well-kept lawns, and there are a further 35 acres of walks and woods that wend all the way down to the sea. Breakfast — local hen's eggs; buttermilk pancakes; French toast with bacon and maple syrup — is a delight. *Ardbear, Clifden, Co Galway, mallmore.com +353 95 21460.*

STAY **Sea Mist House**

€€€ It was after the mighty storms of 1998 ripped the roof off Sea Mist House — literally, not figuratively — that Sheila Griffin and her husband, Rod, and her sister, Mary, decided that they would transform their misfortune into everyone else's good fortune: they would turn their roofless house into Sea Mist B&B. More than two decades later, and Sea Mist is a west coast star, an iconic destination on the Wild Atlantic Way. *Clifden, Co Galway, seamisthouse.com +353 95 21441.*

STAY **Blue Quay Rooms**

€€€ Toby and Pauline are doing the good thing here in the bright, bright blue Blue Quay rooms, a little down the hill from the centre of town as you head to the Quay. With superlative breakfasts, terrific hospitality, vivid modern style and excellent value for money, Blue Quay is the place that pushes all the buttons. A real peach. *Seaview, Clifden, Co Galway, bluequayrooms.com +353 87 621 7616.*

EAT **Mitchell's Restaurant**

€€ When you are in Connemara you want to enjoy a perfect chowder, smoked salmon with a potato pancake, or a hearty bowl of traditional Irish stew. All those dishes are on the menu in Mitchell's, delivered with enviable consistency by a crew who relish their work. *Market St, Clifden, mitchellsrestaurantclifden. com +353 952 1867. Open lunch & dinner.*

EAT The Connemara Hamper

€ Sally and Brendan's lovely shop is a vital place for finding all the good foods of the west coast, and beyond. They source from all the best suppliers, so this is the destination for organic wines, farmhouse cheeses in perfect condition, and excellent coffee. Precious. *Market St, Clifden, Co Galway, connemarahamper.com +353 95 21054.*

EAT Guy's Bar & Snug

€ This is a popular pub, and a good spot to grab a tasty bite of seafood. Make sure to enjoy a pint from the excellent local Bridewell Brewery. *Main St, Clifden, Co Galway, guysbarclifden.com +353 95 21130. Open lunch & dinner.*

STAY Quay House

€€€ Paddy Foyle is arguably the greatest interior designer in Ireland, and staying in the unique Quay House, down at the water's edge in Clifden, brings you up close to the work of a guy who sees design in a different way from everyone else: the man is a true original. 'I remain in awe of the sheer exuberance and lightheartedness of these extraordinary interiors', the blogger Pamela Peterson wrote. What will also leave you in awe is the hospitality, the welcome and the cooking from Julia, Paddy and the family. One of the best. *Beach Rd, Clifden, Co Galway, thequayhouse.com +353 95 21369.*

STAY Clifden Station House Hotel

€€ The bar and restaurant of the Station House Hotel, on the outskirts of pretty Clifden, is actually the old station master's house, and the original railway platform of the Galway-Clifden railway line is a prominent feature. The hotel offers a Railway Children's Club during the summer holidays and school breaks, with a supervised swim club, and there is also a special kids' tea. Excellent staff bring it all together. *Clifden, Co Galway, clifdenstationhouse. com +353 95 21699.*

EAT Steam Cafe
€ Steam is housed in the Station Yard in Clifden, a short walk from the town centre, and it's the sort of simple space that thrives because owners Claire and Alan have great taste. Just look at that Cleggan crab on a thick slice of brown bread, with sweet chilli mayo and a crisp salad. It's as good a thing as you could eat on the west coast. Everything they cook is served with punctilious modesty by a charming team who care deeply about quality. *Station Rd, Clifden, Co Galway @SteamCafeClifden +353 95 30600. Open daytime.*

EAT The Boardwalk Cafe at Clifden Boat Club
€ Simon and Agata offer fantastic views from the dining room, and nicely considered cooking which will draw your gaze away from the sea and towards the delicious things on the plate. *Beach Rd, Clifden, @TheBoardwalkCafeatClifdenBoatClub +353 95 21711. Open daytime, until 8pm.*

EAT Bridewell Brewery
€ Barbara-Anne and Harry have all the sangfroid and energy that you need to be a great craft brewer in Ireland. Recent times have seen the arrival of special occasion beers such as the Navigator and the Pilot, to celebrate the centenary of the Alcock and Brown transatlantic flight, and the dark lager, Festus, to complement their classic Bridewell Red and Bridewell Blond. *Bridewell Lane, Clifden, Co Galway, bridewellbrewery.ie +353 87 127 9346.*

STAY Dolphin Beach
€€€ Clodagh Foyle's elegant B&B is a supremely relaxing place to stay, which is just as well because by the time you have driven along the Sky Road out of Clifden and arrived at the house, chances are your nerves will be shredded: this is a scary road! Excellent breakfasts are a highlight. There is a self-catering lodge in addition to the B&B. *Lwr Sky Rd, Clifden, Co Galway, dolphinbeach.ie +353 95 21204.*

STAY Hillside Lodge

€€ Is that Sting's bass guitar I see before me, in Ruth and Stuart Morgan's B&B, Hillside House, just on the outskirts of Clifden? Indeed it is, and Sting had the decency to autograph the guitar, a tribute to the regard in which Stuart Morgan is held as a guitar technician to the stars. You come here to enjoy the U2 room, or the Beatles' room, and to revel in rock 'n' roll memorabilia. But you also come to enjoy Ruth's brilliant design flourishes, for Hillside is a tribute to a hostess with great design skills. *Sky Rd, Clifden, Co Galway, hillside-lodge.com +353 95 21463.*

STAY Rosleague Manor

€€€ Mark Foyle's house is one of the stateliest and most majestic of all the Irish country houses. Pretty in pink, with the most to-die-for location and setting overlooking Ballinakill Harbour and hard by the winding N59, it is a quintessential part of Connemara, both elegant and yet somehow elemental. The Foyle family are legendary hoteliers in this region, and Mr Foyle shares the family's professionalism in every aspect. He's also taken to rearing his own pigs, so look out for interesting porky bits on the menu. Pristine comfort, good cooking – scallop carpaccio; Connemara lamb; turbot with beurre blanc. *Letterfrack, Co Galway, rosleague.com +353 95 41101.*

Local Heroes – Connemara Smokehouse

Graham Roberts and his wife, Saoirse, have been smoking fish at their remote location – next stop New York! – for more than two decades, perfecting their craft, always getting better, winning admirers, and customers such as Rick Stein, as they have piloted their artisan business through the years. Graham's techniques, with both hot and cold smoking, using beech wood, are meticulous and innovative, and enjoying their smoked salmon, sea trout, tuna, mackerel and kippers should be at the forefront of every WAW traveller's bucket list. *Bunowen Pier, Ballyconneely, Co Galway, smokehouse.ie +353 95 23739.*

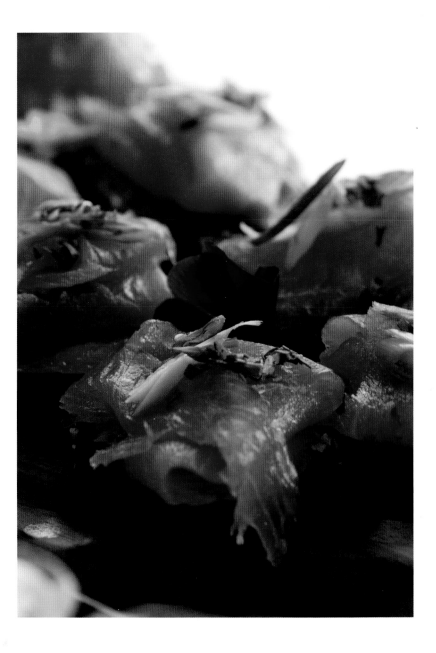

EAT **Paddy Coyne's Public House**

€ Paddy Coyne's is the pub with a gravestone in the centre of the pub. Every year, it's the epicentre of the Connemara Mussel Festival, and there is some good cooking to be enjoyed. If you get lucky, you can hear some really darling singing in the bar. A fantastic pub. *Tullycross, Co Galway, paddycoynespub.com +353 95 43499.*

EAT & STAY **Renvyle House Hotel**

€€€ The psychologists call them Happiness Anchors: those precious times that we enjoy together, or as a family, and which then suffuse our memories with warm and tender feelings of enjoyment and belonging for the rest of our lives. We don't know anywhere that is better at creating Happiness Anchors than Renvyle House, a haven of special moments in time, blessed with beautiful food, great hospitality, and a unique joie de vivre. *Renvyle, Co Galway, renvyle.com +353 95 46100. (See photo overleaf).*

EAT **Kylemore Abbey**

€ The newly installed interactive experience at Kylemore has added another notch of achievement to this extraordinary place. Kylemore is Ireland's Taj Mahal: a palace built for love, by Mitchell Henry for his wife, Margaret. The grounds are quite amazing, acre after acre of beauty carefully maintained by expert gardeners. *Kylemore, Renvyle, Co Galway, kylemoreabbey.com +353 95 52001. Open daytime.*

EAT **Misunderstood Heron**

€ At the edge of Killary Harbour, Ireland's only fjord, is one of Ireland's finest food trucks. The blackboard menu will offer mussels and lamb; pasties and quiches, and sweet things like blueberry cake and Cloudpicker coffee. Kim and Reynaldo cook all of these to perfection, and you sit outside at a picnic table, happily staring down the mouth of the fjord. *Leenane, Co Galway, misunderstoodheron.com +353 87 991 5179. Open daytime. (See photos opposite.)*

EAT The Tavern Bar & Restaurant

€€ Ruth and Myles O'Brien run a veritable paradigm of the modern Irish rural gastropub and restaurant, close to Croagh Patrick in little Murrisk. "We're very proud of what we're doing here at The Tavern," says Ruth. And there, in a nutshell, you have the very reason why The Tavern works, and how it has worked that magic for twenty years. Delightful.
Murrisk, Westport, Co Mayo, tavernmurrisk.com +353 98 64060. Open lunch & dinner.

EAT An Port Mor

€€€ 'We are an Irish restaurant and we serve Irish food, but we also offer a Mayo experience, and we just let the ingredients speak'. That's how chef-proprietor Frankie Mallon describes what he does in An Port Mor, and in his intimate series of rooms he puts that philosophy on the plate, every time. Terrific.
1 Brewery Place, Westport, Co Mayo, anportmor. com +353 98 26730. Open dinner.

EAT Cian's on Bridge Street

€€€ Cian's has been making waves ever since local chef Cian Hayes made over the ground-floor room and started cooking some fine, bistro-savoury food: gin-cured sea trout with smoked eel; goat's cheese with goat's milk ice cream; hake with chorizo hash. Mr Hayes is ambitious, and he's a chef to watch.
1 Bridge St, Westport, Co Mayo, ciansonbridge-street.com +353 98 25914. Open dinner.

EAT Cornrue

€ Patrick O'Reilly bakes a 5-day sourdough in his Cornrue Bakery and it's as fine a thing as you can eat on the WAW. In fact, Mr O'Reilly's breads, and his sweet treats, are so special that they provoke ordinary decent folk to send you pictures and messages to show just how much they are enjoying themselves at Cornrue. *New Rd, The Demesne, Westport, Co Mayo, @cornrue_bakery +353 87 034 8975. Open daytime.*

EAT & STAY · Knockranny House Hotel

€€€€ Knockranny is an ocean liner hotel: you can walk in the door and vanish from the world, emerging several days later, sated with the relaxing comfort and luxury. It's a big place, but retains the feel of a family hotel, thanks to the careful stewardship of owners Ger and Adrian Noonan. Chef Seamus Commons brings home the award for best chef in Mayo on an almost annual basis. His cooking in the La Fougère Restaurant is complex, with lots of ingredients in a single dish, but here is a chef who makes every plate work, and does so with ease and style. *Castlebar St, Westport, Co Mayo, knockrannyhousehotel.ie +353 98 28600.*

EAT · The Gallery Wine & Tapas Bar

€€ Owner Tom has assembled a list of natural, organic and biodynamic wines, and put them alongside the Scrabble board, the chess set, the local foods – look out for Wooded Pig charcuterie – the books and the vinyl records, in a surreal room set just back from the street. *Brewery Pl, Westport, Co Mayo, thegallerywestport.com +353 83 1091138. Open afternoons and evenings.*

EAT · Pantry & Corkscrew

€€ The Pantry & Corkscrew epitomises what a west coast restaurant can offer its customers. Dermott and Janice haul in all the tasty culinary marvels of their hinterland – Mescan beer; Killary Clams; Andarl Farm pork; Velvet Cloud yogurt; Kelly's putog – and then confect these ingredients into original and beautiful dishes. The room at the Octagon is bright and lovely. *The Octagon, Westport, Co Mayo, thepantryandcorkscrew.com +353 98 26977. Open dinner.*

EAT · Savoir Fare

€€ Alain Morice brings stunning technical skills to his superb Mayo artisan foods, so this is where to find stuffed cabbage with beef jus, or country terrine.

Wine evenings and supper club nights show the chef's full batterie of skills and local ingredients joined in the happiest of unions. *Bridge St, Wesport, Co Mayo +353 98 60095 @SavoirFareWestport*

EAT Sage

€€€ Shteryo Yurukov is a very fine cook, and the flavours of his food are clean and bright. Sourcing is meticulous and service under the guidance of Eva Ivanova is pitch-perfect. Informal room, good value, and very popular, so make sure to book. *10 High St, Westport, Co Mayo, sagewestport.ie +353 98 56700. Open dinner.*

EAT Sol Rio

€ Jose and Sinead are professionals to their fingertips, and they make it all seem easy in Sol Rio. 'Customer is king', Sinead once told us, and they put that philosophy into practice every day. Don't miss the Portuguese custard tarts. *Bridge St, Westport, Co Mayo, solrio.ie +353 98 28944. Open lunch & dinner.*

EAT This Must Be The Place

€ Susan and Andrew's smashing café was a winner in Westport from day one, offering great Anam coffee and superb cooking: the signature Kelly's breakfast; beetroot arancini with Joe's salad leaves; bacon croquette with hollandaise sweetcorn fritters with harissa yogurt. The room has terrific energy so, yeah, guess this must be the place you want to be. *High Street, Westport, Co Mayo @thismustbethe-placewestport +353 87 7074500. Open daytime.*

Local Speciality – Mescan Brewery Tours

"Is Mescan everyone's favourite Irish brewery?" asked *The Irish Times*. Well, perhaps, but what is certain is that Bart and Cillian have won a stream of plaudits for their magical beers over the last few years, and that is why you should sign up for one of their illuminating Mescan brewery tours. *Kilsallagh, Westport, Co Mayo, mescanbrewery.com +353 87 418 2628.*

STAY Newport House

€€€€ The tiny back bar in Newport House is one of our favourite places to enjoy a drink, but its charm is just one element of Kieran Thompson's resplendent Georgian mansion. The house is right on the edge of the single street of Newport village and, whilst its original reputation was focused on catering for fishing parties in search of a salmon or a sea trout, the house has always been home to excellent cooking, whilst the wine list is a treasure trove of great bottles. *7 Main St, Newport, Co Mayo, newporthouse.ie +353 98 41222.*

EAT Kelly's Kitchen

€ *The Guardian* called Shauna Kelly's Kitchen "one of the finest artisan cafés in north County Mayo", and you won't find anyone who will disagree with that description. Shauna and her team do everything simply, and well, like their bounteous breakfast – who can resist smoked bacon with French toast and maple syrup? – and what cyclist and traveller on the Greenway wouldn't fall upon a lunch of boxty cake with crispy putog and apple sauce, or a bowl of proper Irish stew served with brown bread. Shauna's gift is the ability to offer us just exactly what we feel like eating. *Main St, Newport, Co Mayo, @KellysKitchenNewport +353 98 41647. Open daytime.*

EAT The Blue Bicycle Tea Rooms

€ Philly Chambers' Blue Bicycle is a real Greenway charmer. The room is pastel and girly, the cooking and baking is soulful, and there is a beautiful courtyard out back for when the sun shines. The Blue Bicycle is just the sort of place you dream of finding as you cycle the Mayo Greenway, with delicious cooking and baking that will restore your pedalling legs, and get you back on the saddle. Don't miss the Princess Grace orange cake. *8 Main St, Newport, Co Mayo, bluebicycletearooms.com +353 98 41145. Open daytime.*

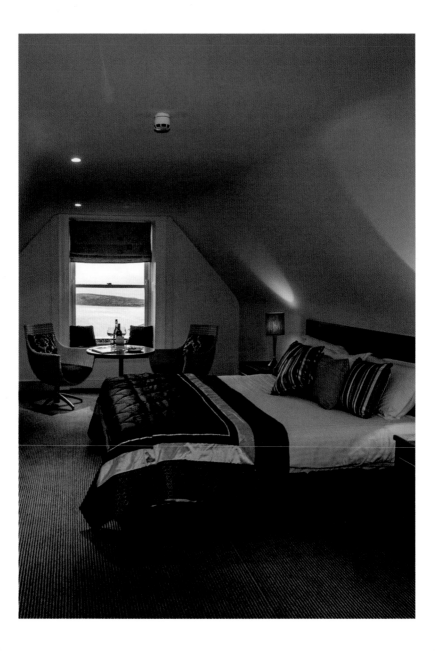

EAT The Grainne Uaile

€ Up at the top of the town, The Grainne Uaile is a lovely community pub, with book clubs, trad music sessions, and nice cooking: slow-cooked lamb hotpot; fish pie; sweet and sour pork. *Meddicott St, Newport, Co Mayo, grainneuailenewport.ie +353 98 41776. Open lunch & dinner.*

STAY Mulranny House

€€ Sarah and Nick's house is high up the hill on the N59, with audaciously beautiful views out over Clew Bay: you could sit and simply watch the waves and sky change all day long. Nick and Sarah are hospitality professionals, and offer light-filled, stylish rooms, superb breakfasts, and they will make up a picnic for anyone hiking or cycling the Greenway. Sweet. *Mulranny, Co Mayo, mulrannyhouse.ie +353 98 36953.*

EAT & STAY Mulranny Park Hotel

€€€ The Mulranny Park is one of those rare destinations that has actually changed the world around it. It is a hotel, of course, and one of the best hotels in the country. But under the tutelage of manager Dermot Madigan, the Mulranny Park has shown itself to be a cultural powerhouse. It has pioneered and powerhoused both the Greenway and the Gourmet Greenway and has made Mulranny, and its breathtaking beaches and landscape, into a destination for food lovers and nature lovers. Mr Madigan and his team also give every guest a masterclass in the art of Irish hospitality. *Mulranny, Co Mayo, mulrannyparkhotel.ie +353 98 36000. (See photo opposite).*

STAY Talbot Hotel

€€€ The Talbot Hotel has a design style every bit as vivid as The G Hotel in Galway, and it's the destination address up in Erris Head. Aside from the décor, however, it's the ambitious and well-executed cooking in the dining room that will have you heading back. *Barrack St, Belmullet, Co Mayo, thetalbothotel.ie +353 97 20484.*

STAY **Léim Siar Bed & Breakfast**

€€ Hannah Quigley's B&B, Léim Siar, enjoys an amazing setting, way, way down Erris Head at Blacksod Bay, at the extremity of the Wild Atlantic Way, the place that readers of *The Irish Times* acclaimed as the best place to go wild in Ireland. Hannah's Irish breakfast is beautifully sourced and perfectly cooked, and the soft fruits from her garden will put real wildness into your day. The house is modern and comfortable, the perfect shelter from the storms of north Mayo. Self-catering apartment also available. *Blacksod Bay, Belmullet, Co Mayo, leimsiar.com +353 97 85004.*

Achill Island

Bervie

Bervie is a series of conjoined cottages that was once an old coastguard station, dating right back to 1932. Elizabeth and John have kept the style of the house simple and comfortable, just as you want from a coastal bed and breakfast. Bervie is as close as the Wild Atlantic Way gets to the wild Atlantic, and if you are a surfer, or a painter who wants to breathe deeply the magic of Achill, then there is no better place than Bervie to inhale that magic. *Keel, Achill Island, Co Mayo, bervieachill.com +353 98 43114.*

The Beehive Craft Coffee Shop

Care, consideration and craft are the currency of The Beehive, and no one can ever tire of enjoying those qualities. Before you try their pear, apple and blackberry tart, or the superb banoffee, make sure to enjoy some local oysters, or smoked mackerel salad, or the bacon and cheddar quiche. "There's very little about The Beehive that isn't delightful", said *The Irish News*, and that's why everyone comes back. *Keel, Achill Island, +353 86 854 2009. Open daytime.*

Local Heroes: **Achill Island Sea Salt** The O'Malley family gather a world-class sea salt, as fine and minerally rich a seasoning as you will find anywhere in the world (achillislandseasalt.ie). **Calvey's Achill Lamb** The Calvey family have been rearing Achill blackface sheep for more than 50 years, and for us this is the most distinctively delicious meat in the country (calveysachillmountainlamb.ie).

The Surf Coast

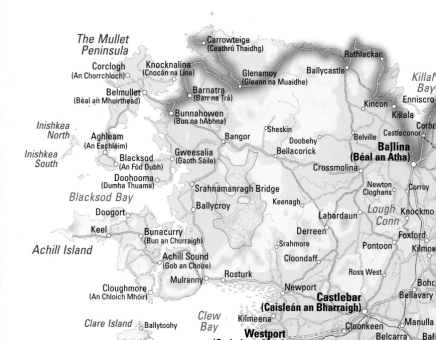

The Mullet
Peninsula

Carrowteige
(Ceathrú Thaidhg)

Rathlackan

Corclogh
(An Chorrchloch)

Knocknalina
(Cnocán na Líne)

Glenamoy
(Gleann na Muaidhe)

Ballycastle

Killal
Bay

Belmullet
(Béal an Mhuirthead)

Barnatra
(Barr na Trá)

Kincon

Enniscro

Bunnahowen
(Bun na hAbhna)

Killala

Corba

Inishkea
North

Aghleam
(An Eachléim)

Bangor

Sheskin

Doobehy

Belville

Castleconor

Bajlina
(Béal an Atha)

Inishkea
South

Blacksod
(An Fód Dubh)

Gweesalia
(Gaoth Sáile)

Bellacorick

Crossmolina

Doohooma
(Dumha Thuama)

Srahnamanragh Bridge

Newton
Cloghans

Corroy

Blacksod Bay

Ballycroy

Keenagh

Lough
Conn

Knockmo

Doogort

Lahardaun

Keel

Bunacurry
(Bun an Churraigh)

Derreen

Foxford

Achill Island

Srahmore

Pontoon

Kilmo

Achill Sound
(Gob an Choire)

Cloondaff

Rosturk

Ross West

Boh

Cloughmore
(An Chloich Mhóir)

Mulranny

Newport

Bellavary

Clare Island

Ballytoohy

Clew
Bay

Castlebar
(Caisleán an Bharraigh)

Kilmeena

Cloonkeen

Manulla

Westport
(Cathair na Mart)

Belcarra

Bal

Roonah Quay

Louisburgh

Aghagower

Ballyhean

Ma

Mullagh

Liscarney

Killavally

Ballintubber

Ballygla

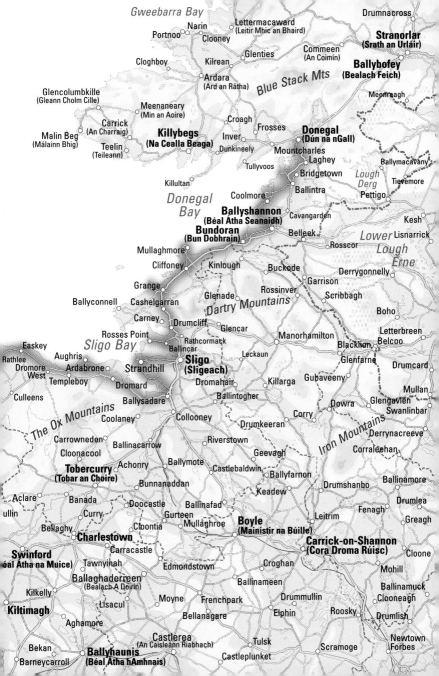

EAT Mary's Cottage Kitchen

€ Sweet, old-style bakery café, Mary's is always welcoming and ageless. *Main Street, Ballycastle, Co Mayo +353 96 43361.*

EAT Polke's

€ A classic traditional public house and shop, which also acts as community centre for visiting artists. *Ballycastle, Co Mayo +353 96 43016.*

EAT & STAY Belleek Castle Hotel

€€€ Belleek is pretty extraordinary, so extraordinary that we selected it as one of the key destinations in Ireland, in our book *Ireland The Best 100 Places*. The original story of Marshall Doran's purchase of the castle is actually just one element of a castle that also offers excellent hospitality and some very good cooking. Not to be missed. *Belleek, Ballina, Co Mayo, belleekcastle.com +353 96 22400. (See photos opposite).*

STAY Ice House

€€€ A super-stylish boutique hotel, right beside the River Moy on the Quay just outside Ballina itself. It's popular for spa breaks, and there are seaweed baths, saunas and hot tubs. Great views across the river from the rooms and the restaurant, as well as an amazing terrace. *The Quay, Ballina, Co Mayo, icehousehotel.ie +353 96 23500.*

Local Discovery – Connacht Whiskey

The first distillery built in Mayo in over 100 years, the Connacht Whiskey Company produces a range of whiskeys – Ballyhoo grain whiskey; Brothership; Spade & Bushel single malt – as well as poitin and gin, as it awaits the maturation of its pot-still whiskey, at present sitting patiently in ex-bourbon barrels, whilst the angels take their share. There is a shop, and organised tours of the distillery are extremely popular. With the Nephin Whiskey Company also taking shape in Lahardane, these are exciting times for distilling in County Mayo. *Belleek, Co Mayo, connachtwhiskey.com +353 96 74902.*

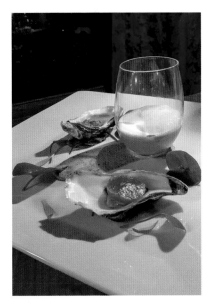

STAY **Waterfront House Hotel**

€€€€ The Waterfront is a happening destination in the surfer paradise of Enniscrone. Dan and Yvonne, and Jason and Sonata, have the youthful energy to power this boutique hotel, with Yvonne's cooking showcasing local artisan foods to great effect: Gaelic escargot with sorrel and spinach risotto; goat's cheese gnudi; rich chocolate cake with peanut butter ice cream. The rooms have amazing views over Enniscrone's beautiful beach. *Cliff Rd, Enniscrone, Co Sligo, waterfronthouse.ie +353 96 37120. Open lunch & dinner.*

EAT **Pilot Bar**

€ Just at the turn for the Cliff Road and the pier, the Pilot is well known for good pints and good music sessions. There is also tasty bar food served and it's a well-run, professional place. *Main St, Enniscrone, Co Sligo, @thepilotbar +353 96 36131. Open lunch & dinner.*

EAT **Pudding Row**

€€ Dervla Conlon cooks and bakes like an artist, and plates her dishes like a painter finishing the brushstrokes of a still life. Every morsel that arrives from the kitchen announces her painterly eye, and painstaking perfectionism. Ms Conlon's cooking defines the best type of modern Irish food: soulful; deeply rooted, tactile and personal. *Main St, Easkey, Co Sligo, puddingrow.ie +353 96 49794. Open daytime.*

EAT **The Beach Bar**

€ When we first visited the Beach Bar at Aughris, 30 years ago, strangers would be met with suspicious silence from the locals drinking at the bar. Today, with surf schools having colonised the beach at Aughris, the bar is buzzy, friendly, always busy. You turn off at Skreen, heading east on the Sligo-Ballina Road, just past the church, and head down to the sea along some lovely, winding boreens. *Aughris, Co Sligo, thebeachbarsligo.com +353 71 917 6465.*

EAT **Shells Cafe and Little Shop**

€€ Shells has spawned a city slicker sibling – Baker Boys, in Sligo town – but for the surfer dudes and ordinary decent folk who pack out the welcoming space of Shells, and its smart patio, Shells will likely remain their first, and truest, love. This modest café and shop is one of the most eclectic and iconic places in the North West, led by the cool-school style of Myles and Jane. The café has everything you want to eat, the shop has everything you want to buy. *Strandhill, Co Sligo, shellscafe.com +353 71 912 2938. Open daytime.*

EAT **Stoked Restaurant**

€€ The two Shanes – Meehan and Hamilton – opened Stoked above the Strand Bar in Strandhill, and quickly made an impact, not least because of the surreal, 'groovy baby!' design ethos of the room. The cooking is powered-up little plates: Strandhill oysters with plum vinegar; squid with burnt lemon basil aioli; Andalusian chicken with PX; Asian pork bao. There is energy and ambition here – a great addition to Strandhill's classy counter culture. *Above Strand Bar, Strandhill, Co Sligo, stokedstrandhill.ie, +353 71 912 2734. Open dinner.*

STAY **Strandhill Lodge & Suites**

€€€ Comfy rooms make the Lodge a good destination for anyone travelling the WAW. *Top Rd, Strandhill, Co Sligo, strandhilllodgeandsuites.ie.*

EAT **Hooked**

€€€ Owners Anthony and Eilish Gray and chef Joe McGlynn gather in the great foods of the North West – Andarl Farm pork; Sherlock's beef from Tubbercurry; White Hag beers; Le Fournil breads; Kelly's puddings – and then prep and prepare them to create a series of must-have Hooked classics. Don't miss the breakfast brioche bap. *3 Rockwood Parade, Sligo, hookedsligo.ie +353 71 913 8591. Open lunch & dinner.*

EAT **Baker Boys**
€€ The edge-of-the-city outpost of the Strandhill supremos Shells Cafe, it will only take a forkful of breakfast shakshuka or a bite of the B Boys veggie burger or a spoonful of slow lamb stew and you too will be re-christening Baker Boys as The Fabulous Baker Boys. *23 Finisklin Rd, Sligo, bakerboys.ie +353 71 910 3570. Open daytime.*

EAT **Bakeshop**
€ Anyone for a MERC sandwich? That's one of the signature dishes of The Bakeshop, in the Lyons department store, and ordering it will get you grilled bacon, fried egg and melted cheddar on ciabatta. Well, that will do nicely. *Henry Lyons & Co, Sligo, +353 71 9142060. Open daytime.*

EAT **Thomas Connolly**
€ The river of history runs through Thomas Connolly's, with its flagstone floor and cosy snugs. The premises first had a licence in 1861, and by 1890 it was in the care of Thomas Connolly, who returned to Ireland having made his money on the railroads in America. Ironically, one of the things that made Connolly's famous was its selection of teas and, if you look behind the bar, you can see the six tea bins. Attention to detail and dedicated hospitality make Connolly's special. *Markievicz Rd, Sligo, thomasconnollysligo.com +353 71 919 4920.*

EAT **Eala Bhan**
€€€ Eala Bhan continues to flourish in the ever-improving culinary landscape of Sligo town because owner Anthony Gray refines, rewrites, adapts and changes with the seasons to make sure that the menus at Eala Bhan are always on point. And, like every great professional, Mr Gray makes it look easy, which is why it is so effortless for diners to enjoy the clubby comfort of this signature Sligo institution. *Rockwood Pde, Sligo, ealabhan.ie +353 71 914 5823. Open lunch & dinner.*

EAT **Fabio's Ice Cream**
€ Fabio's is ace. It's not much more than a little taber-
nacle of a room on Wine Street with a few stools, but
the Italian-style ice creams with mad-cap creative
flavours, like mascarpone and caramelised fig, are
fantastic. *Wine St, Sligo @fabiosicecream +353 87
177 2732.*

EAT **Flipside**
€€ Paul and David have brought a bright sense of
humour, along with accomplished burger skills, to
Flipside. So you can order The Dictator – buttermilk
chicken with kimchi slaw – or The Scorcher – beef
with jalapeno and sriracha. These are craftily
crafted burgers, and the beer list is equally worthy
of attention, with brilliant bottles from local wizards
White Hag and Lough Gill amongst others. *Unit 2,
Embankment, Rockparade, Sligo, flipside.ie +353 71
932 6928. Open lunch & dinner.*

EAT **Le Fournil**
€ Spot the tables and chairs outside on Tobergal Lane
and you have found Clo and Tomasz's Le Fournil,
artisan bakery, chocolatier, and the cutest little
café. The breads are splendid, the chocolates and
patisserie are absolutely top notch, and sitting
outside in the sunshine with a cup of Bean West and
a pear and almond tart is as rive gauche as Sligo
gets. *Tobergal Lane, Sligo @lefournilsligo +353 71
914 9807. Open daytime.*

EAT & **The Glasshouse**
STAY
€€€ The central location of The Glasshouse, and the
good views over the Garavogue River makes it a fine
choice for staying in Sligo. Chef Alan Fitzmaurice
is a leading culinary light in the North West – and
a superlative chocolatier – and his cooking in The
Glasshouse is polished and enjoyable. The decor has
a funky, retro vibe with lots of boldly coloured and
stylised artwork. *Swan Point, Sligo, theglasshouse.
ie +353 71 919 4300.*

EAT ### Kate's Kitchen

€ The best of everything is what they promise at Kate's Kitchen, and that's what you get. Start with some breakfast porridge and a cup of Fixx Coffee, then enjoy a cracking chicken and mushroom pie, or hotpot with red lentil dhal, followed by a swift tour of the counter and the shelves to bring home everything you need. Kate's Kitchen is bounteous and beautiful. *3 Castle St, Sligo, kateskitchen.ie +353 71 914 3022. Open daytime.*

EAT ### Knox

€€€ David Dunne and Patrick Sweeney's Knox met with success right from the day they opened the doors, and the pair have steadily and organically expanded their offer, so you can now go to Knox for breakfast and weekend brunch, lunch, and weekend evenings to enjoy tapas. Everything is well-chosen and thought-through in Knox, from the furnishings to the concise wine list, from the accomplished baking by Stacey McGowan to the vintage lighting. *32 O'Connell St, Sligo, knoxsligo.ie +353 71 914 1575.*

EAT ### Hargadon Bros

€ Hargadon Bros opened its doors in 1868, and they haven't done much to this classic pub in all the years since. You step in the door, and you step back 150 years. Nice pints. *4 O'Connell St, Sligo, hargadons. com +353 71 915 3709. (See photo p 177).*

EAT ### Lyons Café & Bakeshop

€ A simple demand drives the team in Lyons Café. Gary Stafford's cooking is so beloved by their regular customers, that they have to deliver perfection with every dish, every day. Anything less just wouldn't be enough to keep the customers satisfied. And so, every day, they make everything anew. Mr Stafford is a perfectionist, and his food unveils the delights of County Sligo, enjoyed in one of the most charming rooms in the North West. *Quay St, Abbeyquarter Nth, Sligo +353 71 914 2969.*

EAT **Miso Sushi**

€€ The reason why Nae Young Jung's Miso Sushi Restaurant has been such a success is simple: Mr Jung is a charming guy and a charming cook, a man who makes you feel welcome and who cooks excellent Korean – and Japanese – food. This is lip-smacking food, soulful and satisfying, and the menu's offering of Japanese classics just hits the spot – gyoza; sushi sets; shrimp tempura; beef teriyaki; miso pancake; ramen bowls. Mr Jung manages to make these work effortlessly alongside the Korean classics of bibimbap, bulgogi, kimchi pork fried rice, beef rib stew. Friendly staff, and a true sense of effort, engagement and lack of pretension make Miso Sushi a fun event. *Calry Court, Stephen St, Sligo @misosligo +353 71 919 4986. Open lunch & dinner.*

EAT **Osta Cafe and Wine Bar**

€€ Brid Torrades sources from the artisan suppliers who live and work near to Sligo, and her zeal for the local extends even to breakfast, where her foods come from within a 30-mile radius. She has always been the most perspicacious, committed restaurateur, and her tenure stretches over decades. Ever since the early days, her love for fresh local foods has only gotten deeper, and that zeal is evident in every bite of Osta's dishes. *Garavogue Weir, off Stephen St, Sligo, osta.ie +353 71 914 4639. Open daytime. There is a second Osta in W8 tourism and cultural hub in Manorhamilton, Leitrim, w8centre.ie.*

EAT **Sweet As... Diner & Deli**

€ A diner and deli that hosts supperclubs on Friday evenings, Sweet As... is the second Sligo destination created by Carolanne Rushe. The cooking is super-smart and plant-based: cauliflower wings; pumpkin burger on sourdough bun; Caesar wrap; loaded fries with cashew sour cream; blueberry cheesecake. It's a bright, hip room, and the coffee is ace. *8 Markievicz Rd, Sligo, sweetas.ie +353 71 910 4512. Open daytime. Evening Supperclubs.*

EAT € Sweet Beat Café

Carolanne Rushe's Sweet Beat Café is one of those Irish restaurants changing the rules of the game. It's a plant-based food destination, but the customers who eat in this bright and colourful room aren't necessarily vegans or vegetarians: they are just people who want to enjoy vivid, creative food, irrespective of its plant-based philosophy. *Bridge St, Sligo, sweetbeat.ie +353 71 913 8795. Open daytime.*

EAT € WB's Coffee House & Deli Bar

Aisling Kelly not only offers a top-notch coffee shop in WB's, she also offers a unique Sligo oyster experience. You can enjoy Sligo Bay oysters with a glass of wine or local craft beers, and also book an oyster experience, where Aisling will guide you through the secrets of oyster rearing, shucking and eating, followed by a tasting with various dressings. *11 Stephen St, Sligo, @wbscoffeehouse +353 71 914 1883. Open daytime.*

EAT & STAY €€€ The Driftwood

"The coolest autumnal escape..." is how *The Irish Times* described The Driftwood, one of the most stylish getaways on the west coast. The stunning design palette is reason enough to get to Rosses Point, but there is also interesting cooking, from breakfast through lunch and on into dinner service. Try to book a room with a sea view. *Rosses Point, Co Sligo, thedriftwood.ie +353 71 931 7070.*

EAT €€ Harry's Bar & Gastro Pub

Fenton Ewing's great-great-grandfather opened Harry's way back in 1870, so fully five generations of the family have helmed this iconic gastropub, a longevity which is very rare in Ireland. The longevity means that Harry's is a vital part of the Rosses Point community, a place for eating, drinking, making music, and enjoying the phantasmagoric design style whilst you eat. *Rosses Point, Co Sligo @HarrysGastroPub +353 71 917 7173. Open lunch & dinner.*

STAY **Radisson Blu Hotel, Rosses Point**
€€€ Comfortable rooms with views of Sligo Bay and good cooking from chef Joe Shannon in the Classiebawn Restaurant. *Ballincar, Rosses Point Rd, Co Sligo, radissonhotelsligo.ie +353 71 914 0008.*

EAT **Lang's of Grange**
€ Lang's is as authentic a bar as any WAW traveller could hope to find, and the Burke family offer good food in their bar and restaurant – steak sandwich; fish and chips; bangers and mash with onion gravy. *Grange, Co Sligo, langs.ie +353 71 916 3105.*

EAT **Vintage Lane Café**
€ The design elements are artfully mismatched in Ciaran Walsh's café, creating a charming bricolage effect which is very welcoming. The cooking and baking are delicious: perfect BLT; a classic goat's cheese tartlet. There is an eclectic craft and food market held here on Saturday mornings. *Rathcormack, Co Sligo @VintageLaneCafe +353 87 662 2600. Open daytime.*

EAT **Drumcliffe Tea House**
€ The Tea House is where you go for tea and buns and some retail therapy when you have paid your respects to the great W.B. Yeats in Drumcliffe graveyard. *Drumcliffe, Co Sligo, drumcliffeteahouse. ie +353 71 914 4956.*

EAT & STAY **Eithna's by the Sea**
€€€ Eithna O'Sullivan is the great food heroine of Sligo, and her seafood restaurant at the harbour has served as a beacon of creative cooking for more than 20 years. Ms O'Sullivan's cookery pushes the right buttons, often thanks to the inspired use of foraged ingredients, and the menus are strong on the classics. Eithna also runs the comfortable Seacrest Guest House, 50m from the beach. *Mullaghmore, Co Sligo, eithnasrestaurant.com +353 71 916 6407. (See photo p 182).*

EAT Buoys & Gulls

€ Buoys & Gulls is amongst the foremost of the classy, cool destinations that are carving out Bundoran's reputation as a punky Donegal coastline destination, a place for eating, not just for surfing. The attention to detail the guys exhibit means every cup of Joe is a cause for celebration – they put the art in coffee. Deadly, and nice crafts too. *Ocean View, W End, Bundoran, Co Donegal @buoysandgullsbundoran +353 87 9491603. Open daytime.*

EAT Hardy Baker

€ Laura Hardaker is one of the great Irish bakers, a disciplined perfectionist with an artist's lightness of touch. But it's not only the sweet things in Hardy Baker that are blessed with her filigree finesse: everything she cooks here, in the retail park just off the main strip at Bundoran, is fulsomely good: excellent coffees; the classic ham and cheese; the sublime fish finger sandwich; the avocado smash with bacon jam. But those cakes! It's worth the trip to Bundoran just to have the orange and almond cake. *3 Bundoran Retail Park, Bundoran, Co Donegal, hardybaker.ie +353 71 983 3865. Open daytime.*

EAT Dicey Reilly's & Lisnamulligan Burgers

€ Brendan O'Reilly's bar and wine shop in Ballyshannon is one of the vital Donegal destinations. Aside from the good drinks and great craic, Mr O'Reilly also enlists his friend Thomas Hughes to set up at the pub's beer garden to cook the archetypal Donegal burger. These burgers are locavore defined: Mr Hughes' own beef and pork, fed on the grains from Mr O'Reilly's Donegal beers, the virtuous circle of good food, good farming, good eating, and good drinking. Ace, and Mr O'Reilly's wine shop is amongst the best you can find anywhere. *Market St, Ballyshannon, Co Donegal, diceys.com +353 71 985 1371. Burgers served at the weekend. (See photo opposite).*

Northern
Headlands

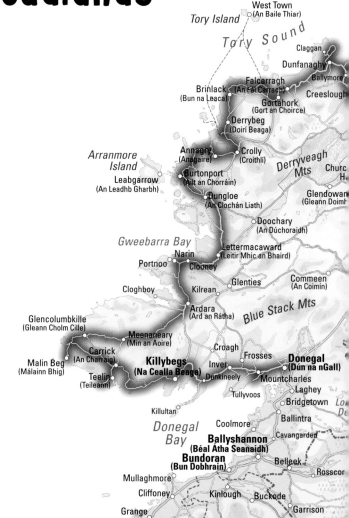

West Town
(An Baile Thiar)
Tory Island

Tory Sound

Claggan

Dunfanaghy

Ballymore

Falcarragh
(An Fál Carrach)
Brinlack
(Bun na Leaca)
Creeslough
Gortahork
(Gort an Choirce)

Derrybeg
(Doirí Beaga)

Arranmore
Island
Annagry
(Anagaire)
Crolly
(Croithlí)
Derryveagh
Mts
Churc
H.

Leabgarrow
(An Leadhb Gharbh)
Burtonport
(Ailt an Chorráin)

Dungloe
(An Clochán Liath)
Glendowan
(Gleann Doimh

Doochary
(An Dúchoraidh)

Gweebarra Bay
Lettermacaward
(Leitir Mhic an Bhaird)
Narin
Portnoo
Clooney
Glenties
Commeen
(An Coimín)
Cloghboy
Kilrean
Ardara
(Ard an Rátha)
Blue Stack Mts

Glencolumbkille
(Gleann Cholm Cille)
Meenaneary
(Min an Aoire)
Croagh
Frosses
Malin Beg
(Málainn Bhig)
Carrick
(An Charraig)
Killybegs
(Na Cealla Beaga)
Inver
Donegal
(Dún na nGall)
Teelin
(Teileann)
Dunkineely
Mountcharles
Tullyvoos
Laghey
Killultan
Coolmore
Bridgetown
Lo
De
Ballintra
Donegal
Bay
Ballyshannon
(Béal Átha Seanaidh)
Cavangarded
Bundoran
(Bun Dobhrain)
Belleek
Mullaghmore
Rosscor
Cliffoney
Kinlough
Buckode
Grange
Garrison

Inishtrahull

Inishtrahull Sound

Malin Head
Ballygorman

Carnmalin

Malin
Arryheernabin
Earra Thire na Binne
Dunaff
Ballyliffin
Culdaff

Clonmany
Gleneely

Portsalon
Carndonagh
Greencastle
Portrush
Bushmills

ownings
(a Dúnaibh)
Tawny
Glebe
Moville
(Bun an Phobail)
Portstewart

Carrigart
(Carraig Airt)
Glenvar
(Gleann Bhairr)
Redcastle
Magilligan
Castlerock
Cloyfin
Ballybogy

Whitecastle
Articlave
Damhead

Milford
Rathmullan
Buncrana
(Bun Cranncha)
Carrowkeel
COLERAINE

Fahan
Lough
Foyle
Aghanloo
Ballymoney

Ray
Burnfoot
Muff
Bolea
Ringsend

ilmacrenan
Ramelton
(Ráth Mealtain)
Culmore
Ballykelly
Limavady

Coolkeeragh
Eglinton
Greysteel
Finvoy

Newtowncunningham
Drumsurn

Letterkenny
eitir Ceanainn)
Manorcunningham
Prehen
LONDONDERRY
(DERRY)
Gortnahey
Garvagh
Kilrea

Carrigans
Drumahoe
Lislea

ashedoge
Pluck
St Johnstown
New Buildings
Claudy
Dungiven

Convoy
Raphoe
(Ráth Bhoth)
Donemana
Ballyneaner
Feeny
Maghera

Lifford
(Leifear)
Artigarvan
Ballynamallaght
Spertin Mountains
Bellaghy

Stranorlar
(Srath an Urláir)
Strabane
Mount Hamilton
Draperstown
Castledawson

Ballybofey
(Bealach Feich)
Sion Mills
Plumbridge
The Six
Towns
Magherafelt

Meenreagh
Ardstraw
Gortin
Ballyronan

Castlederg
Newtownstewart
Greencastle
Dunnamore
Moneymore

Killeter
Drumlegagh
Killen
Mountfield
Creggan
Cookstown
Coagh

allymacavany
Mountjoy
Drumquin
Killyclogher
Tullyhogue
Ardboe

Tievemore
Drumnakilly
Pomeroy
Stewartstown

Pettigo
Ederny
Omagh
Beragh
Cappagh
Carland
Coalisland

Kesh
The Diamond
Seskinore
Maghery

Lisnarrick
Lower
Dromore
Fintona
Eskragh
Dungannon
Laghy Corner

Irvinestown
Auger
Moygashel

Lough
Erne
Ballinamallard
Ballymackilroy
Moy
Benburb
Loughgall

Derrygonnelly
Clabby
Murley
Clogher
Aughnacloy

EAT **Aroma**
€€ Tom and Arturo's Aroma, at the Donegal Craft Village, is but one tiny single room and it is perennially packed. Arturo cooks European staples – risotto; polenta; pasta – just as well as he cooks his native chimichangas and quesadillas – and Tom's baking is superlative: if you haven't had the Tunisian orange cake, you haven't lived. *The Craft Village, Donegal, Co Donegal +353 74 9723222. Open daytime.*

EAT **The Blueberry Tearoom**
€€ The Blueberry is a small, flower-bedecked room where Brian and Ruperta Gallagher take care of everyone as if they were family and where tasty, clever food makes sure that everyone who visits comes back. The honesty and hard work of this couple is inspiring. *Castle St, Donegal, Co Donegal @TheBlueberryTearooms +353 74 9722933. Open daytime, till 7pm.*

EAT **Quay West**
€€ Debbie and Jo are amongst the most experienced restaurateurs in Donegal town, and their move to the sleek, glass-fronted Quay West, with its fantastic views of the bay, has given Quay West a new lease of life. They offer steaks from the char-grill, lots of local seafood, and classics like braised Donegal lamb; and Jo's service is super-friendly. *Quay St, Donegal, Co Donegal, quaywestdonegal.ie +353 74 9721590. Open dinner, from 4pm Sun.*

EAT **The Olde Castle**
€€ One minute's walk from the Diamond, the Olde Castle is home to unpretentious, local seafood, with the sort of menu from chef Marco Letterese that every Donegal destination should offer: Killybegs seafood pies; Lily Boyle's fishcakes; seafood chowder. Red Hugh's restaurant upstairs is more formal, service is svelte, and the food for children is thoughtful. *Tirconnell St, Donegal, Co Donegal, oldecastlebar. com +353 74 9721262. Open lunch & dinner.*

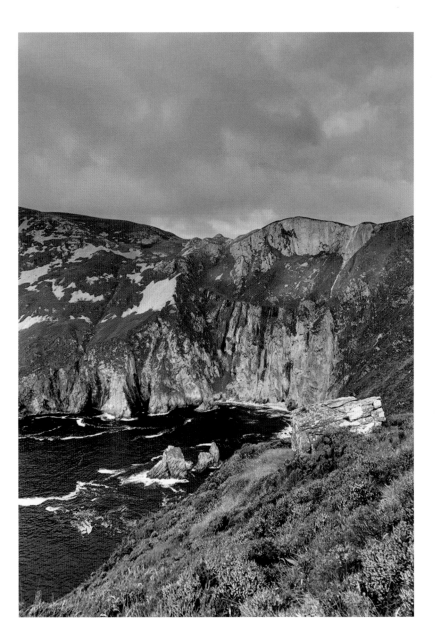

EAT & STAY
€€ **Blas @ The Gateway**

Sited just 500 metres from the centre of Donegal town, the Quinn family's Gateway Lodge offers comfortable rooms and chalets. Their bistro, Blas, is in the original Drumcliffe house, and has a fine refurbished conservatory where you can enjoy the signature Blas burger or steak sandwich and fries. *Killybegs Rd, Donegal, Co Donegal, thegatewaydonegal.com +353 74 9740405. Open daytime.*

EAT
€€ **Old Village Tearoom**

A pretty little room, which also serves as a community meeting spot for book clubs, the Tearoom is a good spot for tea and a sausage roll, and some creamy, sweet homemade cakes and bakes. *1 Lwr Main St, Mountcharles, oldevillagetearooms. wordpress.com +353 86 3426344. Open daytime.*

STAY
€€ **Castle Murray House**

Marguerite Howley and Peter Lawler's lovely B&B gifts guests with some of the most spectacular views you can find in all of Donegal, and sitting in the lounge watching the light ebb over McSwynes Bay is some sort of luminous magic. Good breakfasts and sparkling housekeeping from the hosts make for a delightful destination. *St John's Point, Dunkineely, Co Donegal, castlemurray.com +353 74 9737022.*

EAT
€ **The Seafood Shack**

"Please enjoy the view while you wait" they suggest at the Seafood Shack, and wait you will, lined up at the pier. How they manage such a diverse menu from such a tiny space is remarkable, but then remarkable is what they do here, and everything from their champion chowder – voted Ireland's best – to the sublime calamari is first class. Ms Anderson is a star, and there are plans for a bricks and mortar base in the town. *Shore Rd, Killybegs, Co Donegal @killybegseafoodshack +353 89 2393094. Open 12.30pm-8.30pm. (See photo opposite & overleaf).*

EAT **Ahoy Café**

€ Stephanie and Claire have a nice spot here on the shore road, just outside the town, and the verandah with its umbrellas always beckons on a sunny day, especially when the crab burger is on the specials board. Proper coffee seals the deal. *Shore Rd, Killybegs, Co Donegal @ahoycafekillybegs +353 74 9731952. Open daytime.*

EAT **Kitty Kelly's**

€€€ A fire in mid-2019 damaged the interior of Donna and Remy Dupuis' much-loved destination in Kitty Kelly's, situated right on one of the sharpest bends in all of County Donegal. Food lovers are awaiting news of re-opening, so they can once again enjoy the signature classic that made M. Dupuis famous: prawns and monkfish in garlic butter. *Killybegs, Co Donegal, kittykellys.ie +353 74 9731925. Open dinner & Sun lunch.*

EAT **Brew in Thru**

€ Julie has the cutest, pale green classic Citroen coffee van on the west coast, so make sure to stop at The Salmon Leap, as you cross the Bungosteen River, and get some good coffee and a fresh scone before heading up to the Slieve League cliffs. The coffee, the animated, lively chat with the boss, and the location could not be more charming. *Teelin, Co Donegal @brewinthru2019. Open daytime.*

EAT & STAY **The Rusty Mackerel**

€€€ A visit or an overnight stay at one of Donegal's most famous bars has become an essential stopover for many visitors to nearby Slieve League, and the bar's culinary reputation has grown in recent times, abetting its reputation for terrific music sessions. Martin and Dymphna and the team are ambitious, and when the fiddles are going and the ales are pouring, there is nowhere else to be. *Teelin Rd, Carrick, Co Donegal, therustymackerel.com +353 74 9739101. Open lunch & dinner.*

EAT Nancy's Bar

€€ 'Nancy's is one of those pubs that just captures the imagination', wrote *The Irish Times*. Too right. No fewer than seven generations of the McHugh family have manned the bar in this Donegal icon, one of the county's most legendary pubs, serving tasty food and pulling great pints. It's a must-visit on the WAW, simple as that. *Front St, Ardara, nancysardara.com +353 74 9541187. Open lunch & dinner.*

EAT Charlie's West End Café

€ Charlie and Philomena's café is best-known for its legendary fish and chips, a great demonstration of the fryer's art. Lovely service, simple room, and downright Donegal charming. *Main St, Ardara @Charlie'sWestEndCafe +353 74 9541656. Open lunch & dinner.*

EAT Batch

€ Ciaran McGarvey's unusual mix of coffee house, bar and kitchen allows everyone to have an ace cup of coffee first thing in the morning with one of Batch's famous sausage rolls, and a glass of good wine in the evening along with a bowl of beef and Guinness stew or vegan chilli. We like the ambition – and the style – of Batch, and this is a rockin' addition to Donegal's vibrant food scene. *Main St, Falcarragh, batch.ie +353 83 3639222. Open daytime & dinner.*

Local Heroes — Sliabh Liag Distillery

The makers of An Dulaman gin and the Legendary Silkie whiskey are bringing distilling back to Donegal for the first time in almost 180 years.

The new distillery at Ardara will also feature a visitor centre and with capacity aimed at more than a million bottles a year, there will be plenty of the water of life flowing in Ardara.

Line Rd, Carrick, sliabhliagdistillers.com +353 74 9739875. Distillery tours 12pm, 2pm & 4pm Mon-Sat.

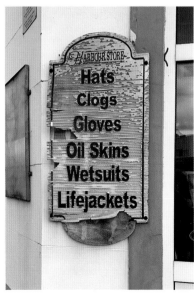

THE HARBOUR STORE

Hats
Clogs
Gloves
Oil Skins
Wetsuits
Lifejackets

DULSE
FRESHLY
DUG
QUEENS

EAT & STAY
€€€ **The Mill**

Derek and Susan Alcorn have been Donegal food pioneers for two decades, and also offer supremely comfortable rooms for travellers. Using local lamb and beef, kid meat, game, shellfish and vegetables in their elegant restaurant means you enjoy the true flavours of the far North West. *Dunfanaghy, Co Donegal themillrestaurant.com +353 74 9136985. Open Mar-Oct. Restaurant open dinner.*

EAT & STAY
€€€€ **Breac House**

The only way to describe the work of Catherine and Niall, of Dunfanaghy's super-stylish Breac House, is to say that they are artists of living, and artists of life. Their experience of living and travelling has been distilled, element by element, into the magnificent architectural and design creation that is Breac House, and they convert the prose of their experience into the poetry of hospitality, which means staying here is unique – a sensuous, sensual, spiritual – and joyful – experience. *Horn Head, Dunfanaghy, Co Donegal breac.house +353 74 9136940. Seasonal. (See photo opposite).*

EAT
€€ **The Rusty Oven**

The Rusty Oven is a local treasure, at the rear of Patsy Dan's pub, and features a magnificent bricolage style of design that is way left-field, and uniquely atmospheric. And anyways, who doesn't love a pizza called The Grill From Ipanema, even if it does feature pineapple. *Dunfanaghy, Co Donegal @therustyoven. Open dinner.*

EAT & STAY
€€€ **Arnold's Hotel & Café Arnou**

The hotel's famous seafood pie is chef Brian McMonagle's signature dish, well worthy of its acclaim, and it's the main course to go for. Just beside the hotel, Café Arnou is a good choice for breakfast and for some imaginative burgers: lamb burger on naan; pulled pork with red cabbage slaw. *Main St, Dunfanaghy arnoldshotel.com +353 74 9136208.*

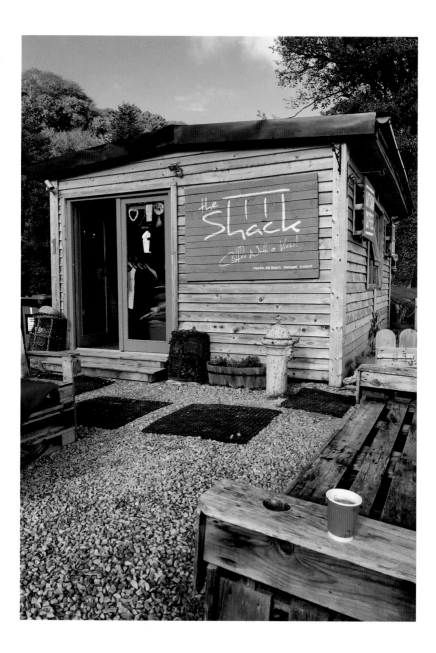

EAT **The Shack**

€ When you discover a perfect beach like Marble Hill Beach, your heart wishes that such an idyll could come with a delightful place to have coffee and something sweet. People, your dreams just came true, because The Shack is that place, Marble Hill is that beach, and Tom and Min know how to fashion that caffeine nirvana. *Marble Hill, Port Na Blagh, Dunfanaghy, Co Donegal, shackcoffee.ie +353 86 7238318. Open daytime. Seasonal. (See photo opposite).*

EAT **Fisk**

€€ Fisk serves what may be the best seafood cookery in Ireland. It's nothing more than a tiny room and a few tables outside the Harbour Bar up the hill at Downings, but Tony Richardson's mastery of his kitchen is total: this guy never drops anything below a stratospheric standard, exemplified by pitch perfect crispy squid; sublime prawns with Café de Paris butter; fish tacos worthy of a Mexican beach; oysters with bloody mary granita; perfect sardines. Lina Reppert and her team manage the seasonal chaos with perfect grace, and Fisk is as good as good gets. *The Harbour Bar, Downings, Co Donegal, fishseafoodbar.com. Open dinner & weekend lunch. Seasonal. (See photos page 203).*

Local Speciality – McNutt's of Donegal

There is a coffee shop adjacent to the showroom of McNutt's, down the hill at the pier at Downings, but what you are really here for is to get your hands on some of the finest examples of Donegal weaving that you can find, sold in their artfully converted showroom. The vivid blush of the colours, the intricacy of the weave, the perfect synthesis of art and craft, makes everything they sell utterly irresistible. *The Pier, Crocknamurleog, Downings +353 74 9155662. Open daytime Mar-Oct.*

EAT **Grape & Grain**

€€ Chris Healy is one of the significant players in Donegal's food culture, heading up both Grape & Grain and the funky Goose & Gander pizzeria in Carrickart. Grape & Grain has several stand-out signature dishes – scallops mornay; the sticky toffee monkfish; Big Green Egg tomahawk steak; the seafood tower; crème brûlée with lemon meringue ice cream. Good cocktails get the evening off to a roaring start. *Downings, Co Donegal @grapeandgraindownings +353 74 9155587. Open dinner weekends.*

EAT **Crepe House**

€€ Emma and Nicola's savoury and sweet crepes, with a cup of good coffee, are just the ticket after a big beach walk: go straight for the blue cheese, pear and walnut, or maybe the Golden Oldie, with bumper hot chocolates for the kids. *Main St, Downings, Co Donegal @crepehousedownings +353 87 6169710. Open breakfast & brunch.*

STAY **Beach Hotel**

€€€ Try to get one of the rooms with views out across Sheephaven Bay and on to Muckish Mountain if you can, when staying at this bright, modern hotel, right in the centre of Downings. *Ostan Na Tra, Magherabeg, Downings, Co Donegal, beachhotel.ie +353 74 9155303. Seasonal.*

EAT **Logue's Goose & Gander Pizzeria**

€€ Chris Healy's pizza restaurant, at the rear of the Goose & Gander pub, has some of the most original pizza cookery you can find: pear William; tarte flambée; pissaladière; sticky toffee pork. These pizzas really push the envelope as to what you can put on a thin tablet of dough, and Mr Healy is a culinary iconoclast. At the height of the season, they can do 300 covers here in the pretty room, so get there early. *Main St, Tirloughan, Carrigart, Co Donegal @LoguesbarGandG +353 74 9155009. Open dinner.*

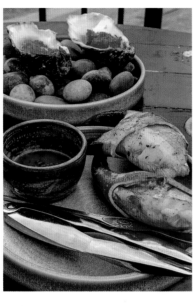

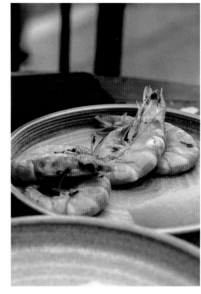

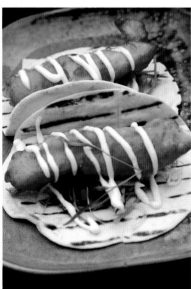

EAT The Olde Glen

€€ A couple of miles outside Carrigart, The Olde Glen is one of the legendary Irish pubs, and a magnet for visitors, so make sure you have a reservation before heading here for dinner. Good, straight-ahead savoury cooking packs the place to the rafters – chicken stuffed with black pudding; hake wrapped in Parma ham; steak with Cashel Blue butter. Nice little tea rooms in the same building, whilst the converted Bia Box offers funky sandwiches, including Mr Tayto Head. *Carrigart, Co Donegal @oldeglenbar +353 83 1585777. Open dinner, from 3pm weekdays, from noon weekends.*

EAT & STAY Rathmullan House

€€€ The Wheeler family have always been mavericks, and have always done their own thing in a maverick way. Sure, Rathmullan is a sumptuous, finessed country house, but it's a country house with a pizzeria, and they bring their own food cart to music festivals like Electric Picnic, which no other country house does. This funkiness means the house is utterly devoid of pretension, a destination for relaxing, eating well, and having a high old time. *Rathmullan, Co Donegal, rathmullanhouse.com +353 74 9158188. Seasonal.*

EAT Belle's Kitchen

€€ Ronnie and Caroline Blake's stylish room offers an enormous range of dishes – everything from breakfasts to crepes to pastas – but Mr Blake's culinary savvy – he is a forager and sourdough bread baker – means standards are high and they have enjoyed considerable success for more than a dozen years. *Pier Road, Rathmullan, Co Donegal @belleskitchen12 +353 74 9158800. Open daytime and dinner.*

EAT Scarpello & Co

€ In a walled yard at the car park on the pier at Rathmullan, Kemal Scarpello's food cart offers toasted sandwiches for the Gods. Put a signature blend of

five different cheeses on a base of Mr Scarpello's peerless sourdough bread, and you have perfection, but do be sure to also try the rosemary and garlic fries, the tomato soup with Cetrone olive oil, and the excellent sundaes. Bliss, for sure. On Saturday evenings at the Scarpello bakery, at Portlough House, they cook up their legendary pizzas, and when it's the right season and you bite into a pizza bianca with Portlough figs and walnut pesto, then there is nowhere else you would rather be. Their breads are widely available throughout the county, and the Saturday morning market at Bridgend. *Portlough House, Rooskey, Newtowncunningham, Lifford, Co Donegal, scarpelloandco.ie +353 74 9156777.*

EAT **Johnny's Ranch**

€ Johnny Patterson's takeaway does everything right: local meats; fresh fish; hand-cut chips. You will have to wait whilst your food is being cooked, but no one minds. Mr Patterson's skills have already won him a clatter of major awards, so order up that steak baguette and the Killybegs haddock and chips, go and sit on the wall by the river, and all is well with the world in Ramelton. You may not be able to step into the same river twice, but you can certainly come back to Johnny's Ranch. *Ramelton, Co Donegal @Johnny'sRanch +353 83 8399305. Open from 4pm.*

EAT & STAY **Castle Grove Country House**

€€€ Head chef Paul Brady's cooking takes its cue from the bounty of the walled garden at Castle Grove House, and the ingredients bloom with that just-picked energy, especially in signature dishes such as the tomato and basil terrine with aubergine relish. Mr Brady also has a love for overlooked ingredients such as rabbit, and garden beetroot. The Sweeney family have run this 300-year-old house with professional élan for three decades, and be sure not to miss the Castle Grove cider. *Ramelton Rd, Letterkenny, Co Donegal, castlegrove.com +353 74 9151118.*

Northern Islands of the Wild Atlantic Way

Aranmore

The largest inhabited island off the W coast of Donegal, it has a population of just over 500 people, and is generally known simply as 'Aran'. It is a Gaeltacht zone, where locals speak Donegal Irish. The island is a place where students come to improve their Irish. Access to the island is by car passenger ferry. The crossing takes 15 minutes. There is a 14-km circular walk of the island.

Tory Island

Nine miles off the coast of Donegal, with an Irish-speaking population of just over 100 people, Tory Island is the most remote inhabited island, rugged and beautiful. It is named for the high tors at its eastern end, and the cliff faces are dramatic and vertiginous. Visitors stay at the 12-room **Harbour View Hotel**, run by the Doherty family. Passenger sea crossings available from Bunbeg and Magheroarty. The island has been home to a significant school of naive painters, started by the artist Derek Hill. *West Town, Tory Island, Co Donegal, hoteltory.com +353 74 91 35920.*

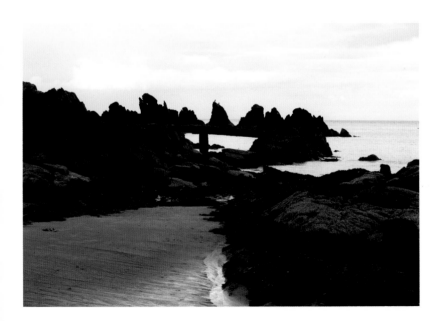

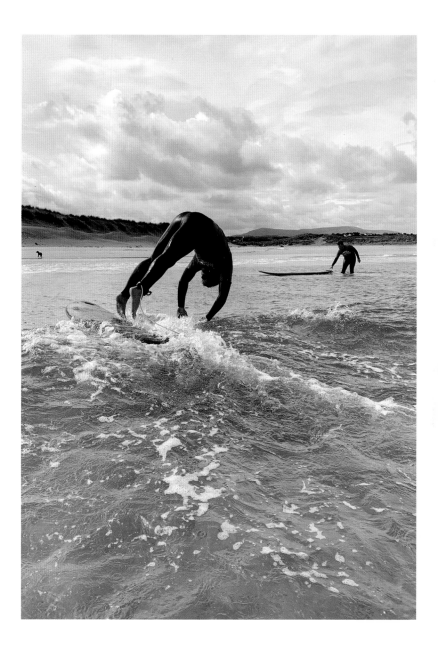

EAT **The Counter**
€ Richard Finney is one of the most dynamic food people in the country, never mind the county, and The Counter is a precious destination. Their posh sausage roll ("Quite possibly the greatest in the world") is a legend, but then everything here is simply extra good. You will disperse a great deal of money in the Deli before you finally leave, but that's okay, because everything is expertly curated, and you need it. *Canal Rd, Letterkenny, Co Donegal, thecounterdeli.com +353 74 9120075. Open daytime.*

EAT **The Lemon Tree**
€€€ Chris Molloy is fast becoming one of Donegal's brightest culinary stars, and his focus on the county's artisan foods make his menus a joy – here is a dude who offers a tasting plate of Donegal goat, and who showcases Mulroy Bay mussels, Haven Smokehouse fish, and Ballyholey Farm vegetables. The five-course WAW menu is something every WAW traveller needs to have eaten. And don't miss the great signature dish of monkfish with pork belly. *32 Courtyard Shopping Centre, Letterkenny, Co Donegal, thelemontreerestaurant.com +353 74 9125788. Open dinner.*

Wholegreen
EAT Wholegreen is a vegetarian and vegan restaurant,
€ so if you are seeking plant-based, healthy dishes you will find them in Anna Good's café: sweet potato and lentil curry; root vegetable chowder with samphire; the signature fresh juices such as Green Monster juice made with cucumber, kale, spinach, lemon, green pepper and basil. *Church Lane, Letterkenny, Co Donegal, wholegreen.ie +353 74 9112296. Open daytime.*

EAT **Florence Food Co**
€ A pretty and attractive room for enjoying coffee and savoury and sweet treats. *63 Main St, Letterkenny, @Florencefoodco +353 86 2218038. Open daytime.*

EAT **9ine Hostages Coffee Co**

€ Daragh McCauley's navy blue van is the spot for superb coffees and some pulled pork on sourdough bread, with a brownie to clinch the deal. Find the van just by the WAW sign at Manorcunningham View. *Derry Rd, Manorcunningham, Co Donegal @9HCoffee +353 83 0369792. Open daytime.*

EAT & STAY **Red Door**

€€€ The Red Door is an elegant country house with a sublime location on the water's edge in Fahan. It's a great spot for afternoon tea, and Sean Clifford's cooking in the restaurant is imaginative and creative: salmon en croute; fillet steak with smoked celeriac purée; Killybegs monkfish with spinach, chorizo and chickpeas. On weekday evenings they have a Grill Night, where Mr Clifford gets all funky with his Big Green Egg. *Fahan, Co Donegal, thereddoor.ie +353 74 9360289. Open dinner & weekend lunch Four double rooms are available for B&B on Saturdays only.*

EAT & STAY **Glen House**

€€ Sonia McGonagle's Glen House, in little Clonmany, is a beautiful house in a beautiful setting, distinguished by the creativity of a dedicated hostess. The house has comfortable rooms, and a fine tea room to relax in after a visit to the Glenevin Waterfall. We can't think of anything nicer than a few days walking on the beaches and through the Urris Hills and the Mamore Gap, then returning to The Glen to end a perfect day. *Straid, Clonmany, Co Donegal, glenhouse.ie +353 74 9376745. Seasonal.*

EAT **The Rusty Nail**

€€ This is a very popular pub for music sessions and entertainment, but you can also get some Urris crab claws on wheaten bread and Mulroy Bay mussels to accompany that creamy pint of stout. *Crossconnell, Clonmany, Co Donegal @TheRustyNailCrossconnell +353 74 9376116. Open dinner & Sun lunch.*

Local Speciality – Donegal Farmhouse Cheese

James and Noreen Cunningham make Kilard Cheddar cheese, using summer pasture milk when they are in production from May to September. The best

Donegal chefs quickly seized on this exciting artisan cheese, so look for Kilard on local menus and good delis, and make sure to bring some home.

EAT Nancy's Barn
€€ Chef Kieran Duey of Nancy's has won the all-Ireland chowder championship on two separate occasions, and followed that with victory in the Chowder Cook Off in Rhode Island. So a bowl of chowder and buttermilk soda bread is reason enough to get to pretty Ballyliffin, even if you aren't a golfer. But there is much more to enjoy here, and Nancy's is a key destination. *Ballyliffin Village, Co Donegal, @nancysbarn +353 86 8432897. Open daytime.*

EAT Claire The Baker's
€ Situated adjacent to the main entrance to the SuperValu shopping complex, Claire's is a vital port of call in 'Carn. This is a homely place, with comforting cooking and soulful baking that always makes the day go better. Claire is one of the Donegal food champions: practical; hard-working; thoughtful; inspiring. *Unit 4, SuperValu, Carndonagh, Co Donegal @weeclairebaker +353 74 9373927. Open daytime.*

EAT Caffe Banba
€ "Just keep heading north until you find us…" is how Dominic and his team describe the extraordinary location of Caffe Banba: right up there at the end of the country, at Banba's Crown where the wild winds whip in, where you are north of north. It's a long way to go, but then you always dreamed that when you reached the end of the road, you would discover a marvellous coffee cart there. And here it is, and everything they offer is only magic. *Ballyhillion, Malin Head, Co Donegal, caffebanba.com +353 74 9370538. Seasonal.*

EAT ### Wild Strands Caife

€ Seaweed, food, adventure is the trio of enticements that William McElhinny offers in the Wild Strands, at Malin's Community Centre. Mr McElhinny's family have a long history of seaweed gathering, and he uses native seaweeds as the USP of his culinary creations, using a wood-fired oven to cook his Ineuran flatbreads, then dressing them with slow-cooked beef, or fresh haddock, and who doesn't want a seaweed brownie and a good cup of coffee. *Malin Head Community Centre, Carnmalin, Co Donegal, @Wildstrandscaife +353 85 1053893. Open daytime.*

EAT & STAY ### McGrory's

€€ What we admire above all about McGrory's is the fact that the team in this far-flung family hotel make everything they do seem natural, elemental, and effortless. Hospitality flows in their blood, so whether you are staying, eating, having a drink, or turning up to hear some rockin' music, the crew always seem to be having a great time making sure that you do too. *Culdaff, Co Donegal, mcgrorys.ie +353 74 9379104. Open lunch & dinner.*

EAT ### Triskele Coffee

€ Characterful, aquamarine converted vintage caravan, offering barista coffee and home-made snacks. *Bridgend Market on Sat, and at Grianan of Aileach @TriskeleCoffee +353 86 3858782. Open daytime.*

Local Speciality – The Donegal Brewers

Whilst the superb Kinnegar Brewing Company, run by Rick Le Vert and Libby Carton, is the best-known of the county's craft breweries, newer arrivals such as Boghopper and the Old Mill Brewing Company are also making finely crafted, distinctive beers. Look out also for Dicey Reilly's brews, from the Donegal Brewing Company in Ballyshannon.

EAT **Kealy's Seafood Bar**

€€ Kealy's of Greencastle has always been one of the great Donegal destinations, a pioneering seafood restaurant where fish and shellfish are showcased to produce delicious dishes: Greencastle chowder; hake with smoked salmon and lemon bon-bon and Noilly Prat beurre blanc; monkfish and cod bake with crab sauce. Kealy's is an ageless, charming restaurant. *The Harbour, Greencastle, Co Donegal, kealysseafoodbar.ie +353 74 9381010. Open lunch & dinner.*

EAT & STAY **The Foyle Hotel**

€€€ Brian McDermott and his team have reinvented the concept of hotel cooking in The Foyle Hotel, and the acclaim that has greeted their work is richly deserved: the food in The Foyle is splendiferous, with every dish offering an avalanche of pure, precisely distilled flavours. Some of the Foyle dishes – the Mulroy Bay mussels with barley and cider; the smoked coley chowder; the Noone's roast chicken; the lamb neck fillet with Parmesan mash; the cod with ham hock – are already contemporary classics, and they exemplify the new Donegal table in all its confident and vivid glory. Service by Brenda McDermott and her team is pitch perfect, the bedrooms upstairs in the hotel are comfy, value for money is excellent, and The Foyle Hotel is a defining modern Irish destination. Not to be missed. *Main Street, Moville, Co Donegal, foylehotel.ie +353 74 9385280. Open breakfast, lunch & dinner.*

EAT **Rosatos Bar & Restaurant**

€€ Just off the main square in the centre of Moville, Rosatos is a clamorous pub, where every inch of the interior is decorated with memorabilia. Rosatos is outsized in all ways – there is a great big menu, there are hordes of hungry eaters and thirsty drinkers, and it's always packed to capacity. *Malin Rd, Moville, Co Donegal @rosatos.bar +353 74 9382247. Open dinner, from 4pm.*

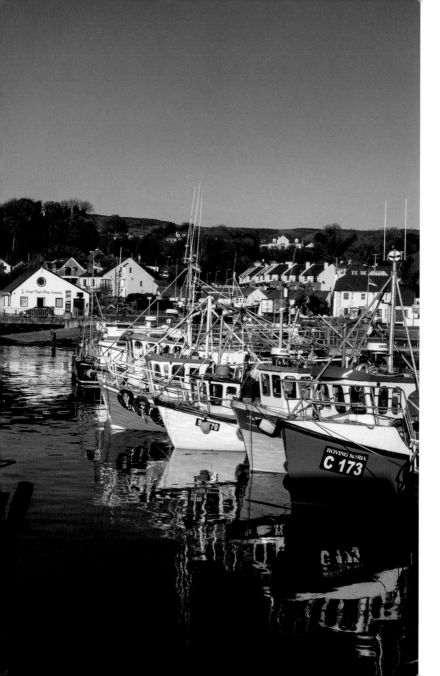

Photo Credits
front cover Eric Valenne geostory / Shutterstock
back cover Sally McKenna

page 44 Niall Dunne / Shutterstock
page 55 Johannes Rigg / Shutterstock
page 95 mikemike10 / Shutterstock
page 99 Flexire / Shutterstock
page 106 Neil Tackaberry / Shutterstock
page 127 A G Baxter / Shutterstock
page 144 Gabriela Insuratelu / Shutterstock
page 165 Wozzle / Shutterstock
page 169 Gary Andrews / Shutterstock
page 178 Scott Woodham Photography / Shutterstock
page 183 Eithne's Restaurant
page 184 Mjmcgrath1

All other photos Sally McKenna.

Companion Volumes
Also published by Collins, *Ireland the Best*
and *Ireland the Best 100 Places*.
For updates and additions, see guides.ie.
We are McKennasGuides on Social Media.